SECRET MARGATE

Andy Bull

with photography by Nick Barham

AMBERLEY

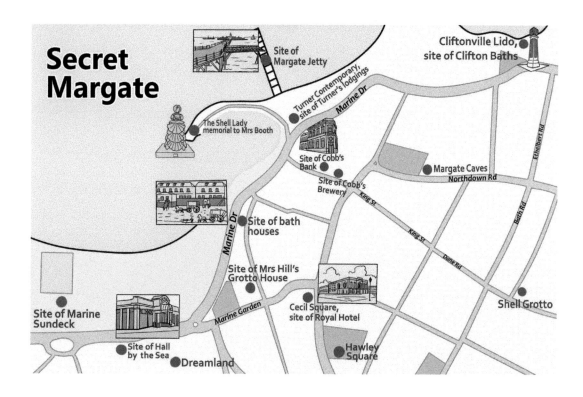

*To all members of the Bull, Barham and Lee families who have made
their homes in Thanet, and especially for my mum, Audrey Bull,
to mark her ninetieth birthday on 2 May 2019*

First published 2019

Amberley Publishing
The Hill, Stroud
Gloucestershire, GL5 4EP

www.amberley-books.com

Copyright © Andy Bull, 2019

The right of Andy Bull to be identified as the Author
of this work has been asserted in accordance with
the Copyrights, Designs and Patents Act 1988.

ISBN 978 1 4456 9205 0 (print)
ISBN 978 1 4456 9206 7 (ebook)

British Library Cataloguing in Publication Data.
A catalogue record for this book is available from the
British Library.

Origination by Amberley Publishing.
Printed in Great Britain.

Contents

Introduction

I first came to Margate, age eleven, in 1967, on a family summer holiday. I still remember every wonderful detail: dad's brand-new, pale-blue Morris 1100 bowling down the Thanet Way; stopping for Coke and sausage rolls at a café just outside Birchington, where Frank and Nancy Sinatra were singing 'Something Stupid' on the jukebox.

Then on into Margate itself. Margate! Lazy days on the beach: hot sand; the Lido pool that kept the sea in when the tide went out; the Sun Deck on Margate Sands; picnics with ever-so-slightly gritty cheese and tomato sandwiches and Lyons' individual fruit pies.

Everything was perfect, even the Cliftonville guest house where at mealtimes the owner, in white jacket and black dickie bow, stood to attention in the dining room, his glinting false eye giving us boarders a sideways look.

Margate was wonderful. Then it died. Now it has come back to life. It was perfect then, but it's even better now.

So here is a celebration of this wonderful seaside town, of its secrets and the many lesser-known stories from its sunburned, salt-and-vinegar past.

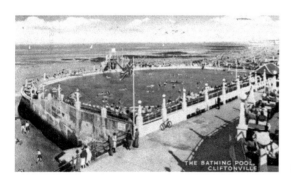

Cliftonville Lido bathing pool, 1950s.

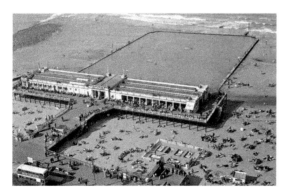

Marine Sun Deck, Margate Sands, 1960s.

1. The Making of Margate

Let's begin not just with a secret, but also with a mystery: a secret royal marriage and a mysterious meeting.

A blue plaque on what is now the Margate Library in Cecil Street records a Margate connection with the man who, when his father George III succumbed to madness, became prince regent, and who would later ascend to the throne as George IV. The plaque, placed here by Thanet District Council, reads:

> George IV
> Prince of Wales
> 1762-1830
> met his bride at
> the assembly rooms
> on this site.

But did he?

Let's consider a couple of things about that plaque. First, the inscription is vague: it doesn't say when they met. Second, it doesn't say which of his wives he met here. Because, although Prince George's 'official' spouse was Caroline of Brunswick, she was actually his second wife. His first, 'unofficial' wife was Maria Fitzherbert, a young, twice-widowed Catholic. When Maria refused to become the Prince of Wales's mistress, he married her in secret, and illegally.

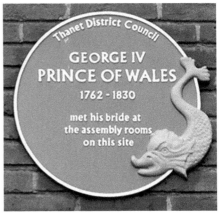

Above left: Margate Library, site of the Royal Hotel and assembly rooms. (Nick Barham)

Above right: George IV plaque on Margate Library.

Which bride does the plaque refer to? Knowing when this meeting took place would give us a valuable clue. Prince George secretly married Maria in 1785, and wed Caroline in 1795.

The assembly rooms, within the Royal Hotel, were certainly the sort of place where royalty, the great and the good gathered in Georgian Margate. Yet most historians agree that Prince George, known to intimates as Prinny, only met Caroline for the first time just before their wedding, and that meeting took place in London, at St James's Palace.

According to W. H. Wilkins, in his definitive *Mrs Fitzherbert and George IV*, the prince had no interest in getting to know Caroline, who was his cousin. He was forced into the marriage in return for his father George III settling his enormous debts, racked up through high living and gambling.

Prinny didn't care who his bride was, as long as his debts were paid, and made no enquiries about Caroline, relying solely upon the recommendation of his younger brother Prince Frederick, the Duke of York, who had seen her eight years before and who spoke well of her.

So, if not Caroline, could it be Maria Fitzherbert who the prince met in Margate's assembly rooms? Again, historians say not. By all accounts, Maria, twenty-seven, met twenty-two-year-old Prince George at the opera in London.

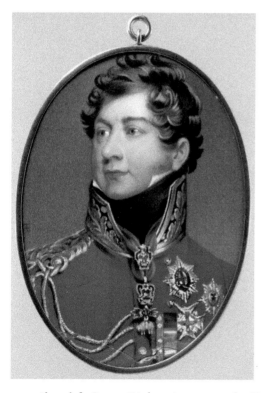 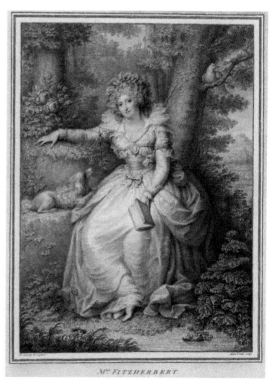

Above left: George IV, the prince regent, by Henry Bone. (Courtesy of the Metropolitan Museum of Art)

Above right: Maria Fitzherbert. (Courtesy of the Yale Center for British Art, Paul Mellon Collection)

Another question is how much time the prince spent in Margate. He famously favoured the rival resort of Brighton, and is perhaps best known for commissioning the spectacular Royal Pavilion, which became his seaside retreat.

However, Margate did have very real royal connections. Prince Frederick, the brother who vouched for Caroline, and who is the grand old Duke of York from the nursery rhyme, had accommodation in York Mansions on the corner of Duke Street. He was the soldier prince who led his forces to a heavy defeat during the Flanders Campaign of 1793–94 against revolutionary France.

Also, Prinny's uncle, Prince William Augustus, Duke of Cumberland, had a residence at No. 13 Cecil Square, just a few yards from the Royal Hotel.

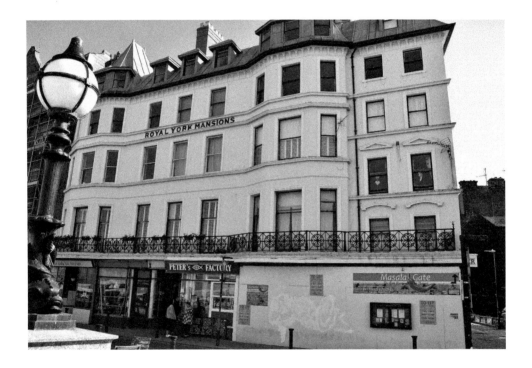

Above: Royal York Mansions. (Nick Barham)

Right: Prince Frederick's blue plaque, York Mansions. (Nick Barham)

Blue plaques mark both houses. Maria Fitzherbert, however, has no memorial. Yet she also has a significant – though little known – Margate connection. She fled here when the prince abandoned her for Caroline. The story of how she came to seek sanctuary in the town is bound up in her relationship with Prince George, and is worth considering in some detail.

After meeting Maria at the opera, Prinny was smitten. He pursued her, and there were whispers that she had become his mistress. She had not, but the pair were genuinely in love. As a token of his sincerity, the prince offered Maria a ring which, because of the significance of accepting such a gift, she refused. However, when Prinny, deeply distraught at this rejection, threatened to commit suicide, she accepted it. The prince was ecstatic, believing this meant Maria had agreed to marry him. Maria, however, painfully aware of the constitutional crisis that would unfold should the couple marry, fled to the Continent.

Under the 1689 Bill of Rights, an heir to the throne who married a Catholic would lose their place in the succession. Additionally, the 1772 Royal Marriages Act stated that the king's consent must be obtained before one of his children married. No such consent had been sought. In any case, it was inconceivable that George III would allow his heir to marry a Catholic. Yet Prinny had Maria tracked down, and married her in a ceremony in the drawing room of her London house in Park Street, Mayfair.

DID YOU KNOW?
Margate's Jubilee Clock Tower, inaugurated in 1887 to mark Queen Victoria's Golden Jubilee, incorporated a mast up which a copper time ball was raised, then dropped at precisely 1 p.m. so that ships at sea, and townspeople, could set their clocks by it.

Serious salt-spray damage put it out of action from 1920, but in 2012 Margate Civic Society raised £16,000 to restore it in commemoration of Queen Elizabeth II's Diamond Jubilee. The Cumbria Clock Company, which looks after Big Ben, computerised the mechanism, and the time ball once again drops at 1 p.m. each day.

Although the marriage could never be recognised by the royal family, the couple lived happily together for nine years until, in 1794, he agreed to marry Caroline of Brunswick. How to tell Maria? The prince took the coward's way out: he sent a note.

Wilkins recounts: 'The Prince had arranged to meet her at dinner at the Duke of Clarence's at Bushey.' Maria had just received a loving note from Prinny and 'had no idea anything was wrong between them'. When she arrived 'she found the Prince was not there. But a letter was given to her, saying he would not enter her house again'.

Within a week, Prinny came to his senses; losing Maria was too painful to bear. While the marriage to Caroline would go ahead, he desperately wanted to keep seeing Maria. An emissary, Admiral Jack Payne, was sent to Maria's country house at Richmond – Marble Hill. As he had done many times before, the prince sought to gain her sympathy by feigning illness.

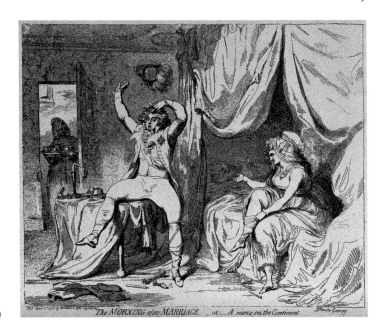

James Gillray's
*The Morning
after Marriage*:
*Prince Regent and
Maria Fitzherbert.*
(Wellcome Collection)

Payne learned that Maria intended to seek solace in Margate. In one of his notes to Prince George, dated 29 July 1794, Payne wrote:

> I feel the strongest necessity of remaining here as long as I can get Mrs Fitzherbert to stay, who would have left this place for Margate this morning, but has now consented to stay till tomorrow evening and to go to London. Her mind is very much disturbed at the thought of your being ill, but be assured, my dear Prince, that her dread of writing herself to you again, in my mind seems to arise more from the persuasion of the impossibility of your being happy in future than any resentment of what is past.

The next day Payne wrote again. Maria had gone to Margate but had been persuaded to write first to Prinny: 'I am not sorry I stayed till Mrs Fitzherbert's departure as I did not get her into a state of mind tranquil enough to write a letter till 2 o'clock in the morning of her leaving this and which I put in the post here to avoid any changes that might prevent its being sent.'

News of the separation gradually filtered out. There was speculation Maria had fled to Switzerland, but on 23 July *The Times* reported:

> We have hitherto forborne to mention the report in circulation for many days past of the final separation between a gentleman of distinguished rank, and a lady ... until we had the opportunity to ascertain the facts beyond all doubt.
>
> We are now able to state from the most undoubted authority, that a final separation between the parties in question has actually taken place ... Mrs Fitzherbert has no intention of retiring to Switzerland, as has been reported. She is looking out for a house at or near Margate where she means to reside for six months.

DID YOU KNOW?
The Mechanical Elephant pub on Marine Terrace is named after one of the strangest Margate attractions: an actual mechanical elephant that operated on the promenade below The Fort in the 1950s. The machine, a full-sized replica on which eight children could sit on bench seats suspended either side of the elephant's back, was powered by a 10 horse-power petrol engine and could reach 27 miles per hour. The exhaust ran down its trunk. The elephant was created by Frank Stuart in Essex, and was later sold to comedian Peter Sellers, who collected unusual vehicles.

Courtiers were concerned that Prinny might follow Maria to Margate. In August, the prince travelled to London from Brighton to spend time with Lady Jersey, his mistress. His return to the capital was a great relief to those who hoped he would not take up with Mrs Fitzherbert again. Lady Jersey's biographer Tim Clarke writes in *The Countess: The Scandalous Life of Frances Villiers, Countess of Jersey* that on 22 August William Churchill wrote to Prinny's envoy Jack Payne: 'He [the prince] was in town for one week from the 9th which time I find was taken up with Ly J [Lady Jersey]. I thought a trip to Margate would have taken place; fortunately for Mrs F it did not.'

With Maria dropped, wedding preparations went ahead, and George married Caroline on 8 April 1795. Yet, the day before the wedding, Maria saw Prinny from the window of her Richmond house. He cut a pathetic figure, cantering back and forth on his horse, and only left after darkness had fallen.

Marriage to Caroline proved a disaster and, by 1799, Prinny and Maria were together again. Until 1807 they lived in a house Maria bought in Brighton, close to where Prinny was building his Royal Pavilion, finally parting in 1811 when the prince found a new lover, Lady Hertford.

The prince never forgot Maria. In his will he wrote:

I now bequeath, give and settle at my death all my worldly property of every description, determination and sort, personal and other, as shall be described, to my Maria Fitzherbert, my wife, the wife of my heart and soul. Although by the laws of this Country she could not avail herself publicly of that name y [yet] still such she is in the eyes of Heaven, was, is and ever will be such in mine.

How differently things might have turned out if Prinny had rejected Caroline and followed Maria to Margate!

The Royal Sea Bathing Hospital

There was a curious connection between royalty and one of the diseases being treated at the Royal Sea Bathing Hospital. In the eighteenth century, scrofula, a skin disease caused by tuberculosis, was known as 'the King's Evil' and many doctors believed the only way to cure it was to be touched by a member of the royal family.

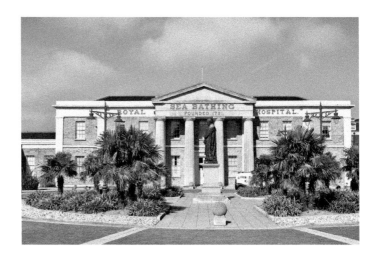

Royal Sea Bathing
Hospital. (Nick Barham)

In fact the future George IV helped in a far more practical way. In *The History of the Royal Sea Bathing Hospital Margate 1791–1991*, F. G. St Clair Strange writes that just six-and-a-half weeks after the foundation of that charity, and long before the hospital was built, 'His Royal Highness (the Prince of Wales) accepts the Patronage of the Margate Infirmary.'

As patron, the prince was head of the organisation handling the affairs of the hospital, and actively involved in its governance, helping choose the chief surgeons.

Sea bathing had become increasingly fashionable and popular since the 1730s among the well-off, but Dr John Coakley Lettsom wanted to bring its benefits to ordinary people. The Royal Sea Bathing Infirmary for the Scrofulous Poor of All England – later renamed the Royal Sea Bathing Hospital – was the world's first, and also the first open-air sanitorium.

This philanthropic Quaker was inspired by Dr Richard Russell's 1752 'Dissertation on the Use of Seawater in the Diseases of the Glands', which advocated both the benefits of sea bathing and of drinking seawater. The hospital, at Westbrook, just to the east of the then town boundary, had a horse-drawn bathing machine in which patients could be taken into the sea. Fresh air and sunshine were also prescribed, and patients would be wheeled in their beds from the wards into open galleries.

It was claimed that almost any illness could be cured with the application of seawater, internally and externally, but it was considered particularly effective in the treatment of glandular and respiratory conditions. In fact, it was the fresh air and good food that brought most benefit to Lettsom's patients.

In his *Essays of Elia*, Charles Lamb tells of meeting a sick young man aboard a ship travelling to Margate:

It was a lad, apparently very poor, very infirm, and very patient … He was as one, being with us, but not of us. He heard the bell of dinner ring without stirring; and when some of us pulled out our private stores – our cold meat and our salads – he produced none, and seemed to want none. Only a solitary biscuit he had laid in; provision for the one or two days and nights, to which these vessels then were oftentimes obliged to prolong their voyage…

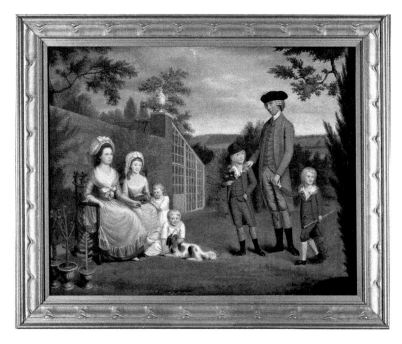

John Coakley Lettsom with his family. (Wellcome Collection)

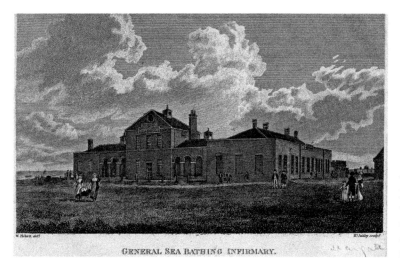

GENERAL SEA BATHING INFIRMARY.

The Sea Bathing Infirmary in the eighteenth century. (Wellcome Collection)

We learned that he was going to Margate, with the hope of being admitted into the Infirmary there for sea-bathing. His disease was a scrofula, which appeared to have eaten all over him. He expressed great hopes of a cure; and when we asked him, whether he had any friends where he was going, he replied, he had no friends'.

The original hospital building was designed by Revd John Pridden, an antiquary and amateur architect. Patients were admitted after an examination by a medical board in London, and no fees were charged.

Thirty patients could be accommodated in wards with either nine or six beds, built either side of a two-storey staff accommodation and office block. It was enormously oversubscribed, and in 1816 capacity was increased to ninety beds. In the 1840s another wing was added – this time two storeys.

For its first fifty years the hospital was only open in summer, but in 1853 a horse-driven pump was installed to bring seawater up to indoor baths, and patients could be treated all-year round. Wards for children followed in 1857–58, plus a school, a dining hall and a house for the governor.

All this piecemeal building had given the hospital a disjointed appearance. To bring architectural coherence, all the buildings were raised to two storeys and given Greek revival styling. A Doric portico was created over the west entrance, and subsequently moved to the south front, where it can still be seen today.

More substantial additions were made in the 1880s, funded by Sir Erasmus Wilson, one of the first doctors to specialise in skin diseases. Sir Erasmus was a director of the hospital and had a house in Westgate-on-Sea (of which more in Chapter 7), a couple of

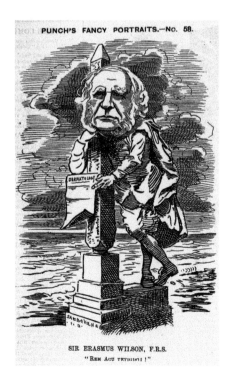

Sir Erasmus Wilson in a *Punch* cartoon.

miles west of Margate. With his £30,000 donation, more wards were added, plus a heated swimming pool and chapel. By this time around 900 poor patients were being treated each year. A statue of Wilson, erected in 1896, stands before the main entrance.

According to the Dictionary of National Biography we all owe a debt to this man: 'To Wilson's teaching we owe in great measure the use of the bath, which is so conspicuous a feature in our national life, and to his advocacy is to be attributed the spread of the Turkish bath in England.'

By the early twentieth century, sea bathing and swimming in seawater pools was being phased out. Treatment focused on fresh air and sunshine, with patients spending as much time as possible on the open, west-facing balconies.

During the First World War, wounded and shell-shocked British and Belgian servicemen, in addition to those suffering from tuberculosis, were treated at the hospital.

The final addition to its facilities was a nurses' home, built in 1922 and then extended from two storeys to four in 1935.

In recent decades, the story of the hospital – as with so many other wonderful buildings we shall explore in these pages – was one of seemingly remorseless decline followed, in the twenty-first century, by rescue and restoration.

By the 1990s the hospital's future was uncertain. It closed in 1995 when services were transferred to Thanet District General Hospital, and the buildings were left empty and rundown. Then, in 2001, a planning application was submitted to convert the hospital into a complex of 164 luxury apartments. Since then, new blocks have been built in the grounds and the site transformed into an upmarket residential area.

The First Tourists

From its inception, Margate was almost uniquely a place frequented, according to an early guide, by both the high and low, rich and poor, sick and sound. All had one pleasure in common: sea bathing.

Enterprising Margate merchants competed to provide the most comfortable way for visitors to enjoy the sea. In 1736, Thomas Barber, a carpenter, placed an announcement in a local newspaper in which he said:

> Whereas bathing in sea-water has for several years, and by great numbers of people, been found to be of great service in many chronical cases, but for want of a convenient and private bathing place, many of both sexes have not cared to expose themselves to the open air; this is to inform all persons, that Thomas Barber, carpenter, at Margate in the Isle of Thanett [sic], hath lately made a very convenient bath, into which the sea water runs through a canal about 15 foot long. You descent into the bath from a private room adjoining to it.

In fact, most visitors (known as bathers) took to the sea in bathing machines – cabins on wheels pulled by horses, often accompanied by a guide, and would be drawn 200 or 300 yards out into the bay. The first Margate man to take a bather into the sea in such a machine was Zechariah Brazier, in 1770.

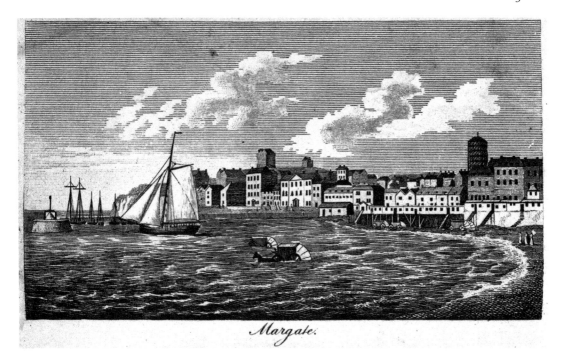

Sea bathing at Margate in the eighteenth century. (Wellcome Collection)

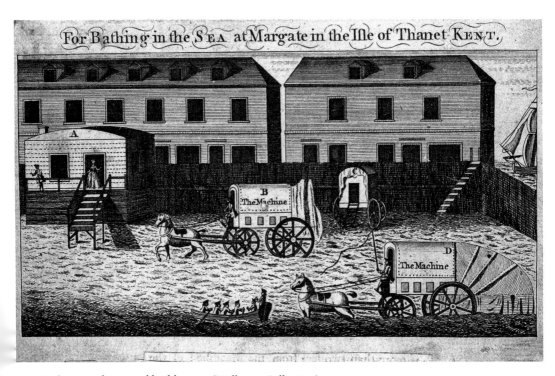

Bathing machines and bathhouses. (Wellcome Collection)

DID YOU KNOW?
Margate was the first resort to offer donkey rides, in 1790. Ladies particularly enjoyed them, and a small boy would run behind, using a stick or whip to speed the animals along. Donkey races were also a feature of beach entertainment, with much betting on the outcome. Photographers from the Sunbeam agency used seven life-sized model donkeys as props for the snaps they took of happy holidaymakers in the 1940s to '60s. Donkey rides disappeared from Margate in 2008 when Nick Gunn, the last remaining licence holder, gave up for family reasons. The donkeys retired to a field at Whitstable.

In 1795 an account of the miraculous cure, following bathing, of a Mr Sanguinetta was published in a book called *A Practical Essay on the Good and Bad Effects of Sea-water and Sea-bathing*.

Sanguinetta, aged twenty-four, was said to be paralysed from the neck down and 'was reduced to a mere skeleton'. Brazier had to carry the man on his back to the bathing machine and, when he bathed, three men plus his own wife had to assist him.

When he was stripped, two of the men threw him into the sea as a log, while he and the other man stood in the water to receive him, and keep his head above water...

After the seventh or eighth time he was thus bathed, he began and made a small struggle with his hands and feet in the water ... In eight weeks he could lift the spoon to his mouth, take hold of his two crutches, and walk across the room: the tenth week he crept down stairs to the parlour, where, getting into a passion with his wife, he threw one of his crutches across the room at her. After this he walked to the bathing-machine with one crutch only ... then he struck out and attempted to swim. After that he threw away his second crutch ... took up his German flute and played; which instrument he had been a great master of...

After thirteen weeks bathing, two or three times a week, he returned to London with his wife, perfectly restored, without the smallest assistance of medicine at Margate.

Bathing machines were not invented in Margate, but they were perfected here. In 1753, Benjamin Beale designed a modesty hood which, when lowered from the front of the machine to the waves, gave complete privacy for the naked bather. Sea bathing became so popular that there were long waits for a machine. The proprietors needed to entertain their customers while they waited, and bathing houses opened along the west side of Margate High Street, which at the time was right on the shoreline. Here, bathers would relax, chat, drink seawater, read newspapers, even play the piano while they awaited their turn in a machine.

The first two bathing houses opened in the 1750s. In 1763 there were three, with eleven bathing machines, and by 1797 there were seven. One, Hughes' Bathing Room, offered hot seawater baths.

A fierce storm in 1808 destroyed these buildings, but they were quickly rebuilt, and the run of single-storey shops at the west side of the lower end of the High Street mirror the look of the bathing houses. At the time, they stood on a low cliff above the beach and had steep steps leading down to the sands, where bathing machines would be drawn up. Marine Drive now runs between the High Street and the modern shoreline.

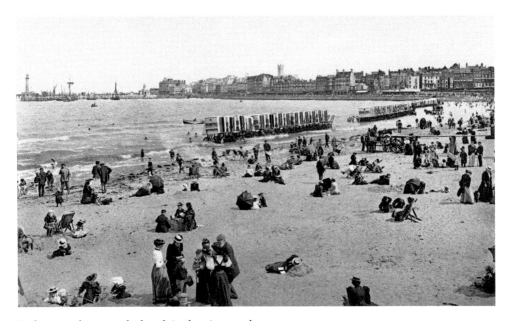

Bathing machines on the beach in the nineteenth century.

These High Street shops replace a row of bathing houses.

The almost-forgotten remains of Margate's most sophisticated bathing complex now lie hidden beneath Cliftonville Lido, just east of Margate Harbour. Known until 1938 as Clifton Baths, this remarkable establishment boasted, according to an advertisement, 'A novel suite of bathing rooms, excavated from the solid chalk rock ... A spacious room fronts the sea, and communicates with a terrace a hundred feet in length.' The facility, created in 1824, boasted warm, shower and vapour baths plus sea bathing accessed through tunnels.

In the 1920s the baths were taken over by John Henry Iles, who we will learn more about in Chapter 4. He expanded and updated the attractions, creating several levels of bars, cafés and restaurants, overlaying the Gothic exterior of flint and stone with jaunty art deco styling, and creating a large open-air swimming pool projecting into the sea.

However, the enterprise later suffered a steep decline and closed thirty years ago. In 2008 the hidden facilities, which comprise one of the earliest surviving seawater bathing establishments in the country, and the only one cut out of the cliffs, were given a Grade II listing. Unfortunately, the Lido remains one of the wonders of Margate that has yet to be restored. There have been various plans, including for a sea life centre in 2014, but none have come to fruition.

One reason Margate developed as a sea-bathing resort was that the generally southerly breezes ran offshore and calmed the waters, but the practice could still be treacherous.

The *Kentish Gazette* of 29 September 1797 reported one near-fatal incident:

A droll adventure took place at Margate last week, the commencement of which was nearly tragical, but it fortunately, for the persons concerned, terminated in a farce. By some neglect on the driver, a bathing machine in which were two ladies, got afloat and it being the ebb of the tide, was drifting fast to sea. Their cries attracted the attention of three gentlemen, who were amusing themselves in swimming. They got into a boat, and pushed off to the succour of the afflicted fair ones, to whom they presented themselves literally in puris naturalibus. Life is sweet and the damsels were happy to be rowed to shore without once daring to look at their brave deliverers.

The fact that bathers were naked attracted ribaldry, and some unwanted attention. What today would be called voyeurism was seen as harmless fun. A James Gillray cartoon of 1815 depicted a group of leering old men looking through telescopes as naked women were knocked by the waves from the privacy of their bathing machines' hoods. The title: 'Summer Amusement at Margate, or a Peep at the Mermaids'.

Other newspaper reports suggest that women bathers could become the victims of sexual violence. In the *Kentish Gazette* of 19 November 1870, a report headlined 'Margate - Attempted Suicide' recounts how Emma Hunt, a young servant, was found by a watchman lying by the water's edge near Mr Pettman's ladies-only bathing establishment. 'He attempted to rouse her, and enquired as to how she came there. She ejaculated "Oh, how cruel! How cruel!" but appeared to be ignorant of what had transpired after she left church the previous evening.'

Although the case was portrayed as one of attempted suicide, a letter published in *Keble's Margate Gazette* on 6 January 1871 suggests a cover-up of a violent attack and calls

for an inquiry. The correspondent says: 'The public have indisputable right to claim, a public enquiry in this case, or demand a satisfactory explanation why this particular case should be exempted from the legal course usually taken in such matters.'

DID YOU KNOW?
Jane Austen's cousin Eliza visited Margate, for her son's health, in January 1791. Despite the frost and snow, he went swimming. Eliza wrote to Jane that the place was very empty but that she occupied herself with reading, music and drawing.

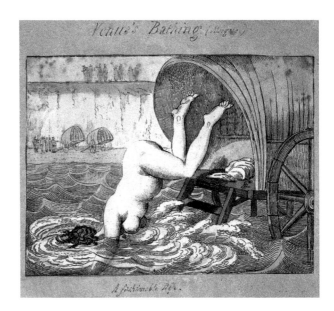

Venus's Bathing. A Mishap at Margate. (Wellcome Collection)

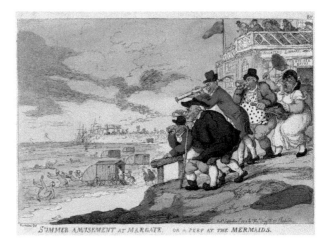

Summer Amusement at Margate, James Gillray. (Royal Collection Trust)

The King of Margate

Francis 'King' Cobb came from humble beginnings. Yet this publican and baker, who lived from 1726 to 1802, became one of the most important men in Margate and founded a brewing, banking and shipping dynasty that played an enormously important part in the transformation of Margate from obscure fishing village to one of the most fashionable, and popular, watering places in the country.

A blue plaque in King Street marks the grand home he built with the riches from his businesses. Francis bought up much of King Street, housing not just his brewery here in 1763, on a 3-acre site running back from King Street alongside Cobb Court, but also his personal hatter, tailor and stables.

'King' Cobb's humble beginnings were also present in King Street in the shape of the Fountain Inn, on the corner with Fort Road, where he was landlord before he made his fortune.

In the first indication that the Cobbs were good at obscuring their humble origins, when he founded Cobb's Bank in 1785, Francis built it where the inn had stood – a demonstration that he could overwrite his past in a very concrete way. The building is now a gallery and community space.

Francis 'King' Cobb's house, King Street. (Nick Barham)

In *The Cobbs of Margate* Toby Ovendon writes: 'So much was their dominance that one contemporary claimed the family had so [closely] identified itself with the history of the town, that one [could not] be separated from the other.'

DID YOU KNOW?
Margate had the first seaside boarding house, in 1780, and was the first resort to introduce deck chairs, in 1898.

Conscious that they were now rubbing shoulders with the very highest in the land, Cobb's son, Francis Cobb II, and grandchildren sought to rewrite their past, adopting the genealogy of another, more distinguished but by then extinct Kentish family with the same surname.

However, the thing that truly worried the second and third generations of the dynasty was Francis Cobb I's connections with the slave trade.

Toby Ovendon writes that while Cobb Snr had been an infrequent churchgoer, his son, 'became awakened to a sense of the supreme importance of religion after the tragic death of his first wife, and his four sons were similarly evangelical ... Conscious that the iniquity of the fathers could be visited upon the children unto the third and fourth generation, the grandchildren became increasingly concerned about the business empire they had inherited.'

What sins were they so anxious to make recompense for? Ovendon questions how Cobb, who for fourteen years had been a mere gingerbread baker, had obtained the £200 needed – a large sum in those days – to found his brewery, and how he managed in just two years to buy the freeholds of his extensive rented property and expand his business so rapidly at a cost of £60,000.

Ovendon suggests that Francis I may have been involved in some 'shady' enterprises, including smuggling. He was certainly fined for evading customs duty. Had the Cobbs also profited from slavery? Ovendon writes:

Cobb's shipping agency – which co-ordinated maritime activities like provisioning ships, assisting those in distress, and repairing and salvaging wrecks – profited greatly from the contemporary slave-economy. In September 1782, the Emperor, travelling from Jamaica to London, ran into difficulty [off Margate] ... and its valuable cargo of slave-produced sugar, rum, pimento and cotton was salvaged and stored in the family's warehouses. Similarly, in 1784, the Cobbs acted as 'agents of the Owners of the Cargoe [sic] of the Matilda from Jamaica laden with Sugar & Rum' when it was wrecked off Margate ... The archives reveal countless instances of the shipping agency servicing vessels connected with the slave-economy ... Significantly, the family once came into direct contact with slavery through their agency, arranging for the board and lodgings of twelve wrecked Negro slave sailors whilst their ship was being repaired and arrangements made for their transportation.

The family's other businesses were also implicated, Ovendon believes. They sold rum produced by slaves in their chain of tied pubs, and Cobb's Bank very likely profited from slavery through extending credit to slave traders and plantation owners.

Perhaps to atone for this, Francis II and his sons joined the campaign for the abolition of slavery. In 1825 they took key roles in the Margate Anti-Slavery Association, very possibly funded the organisation, petitioned Parliament, organised and attended mass meetings, and operated a sort of lending library of antislavery literature. They also spread their philosophy throughout their businesses and encouraged employees to take up the cause.

The Cobb family burial plot, with its ornate memorial, can be found at St John the Baptist Church, at the southern end of the High Street.

DID YOU KNOW?
The cockney duo Chas & Dave had a hit single titled 'Margate' in 1982. The song was actually written for a Courage Best Bitter TV commercial, but made No. 46 in the charts. It celebrated the joys of a coach trip to the town, eating jellied eels at the cockle stall, drinking beer on the pier and strolling along the prom. It ends with: 'You can keep the Costa Brava and all that palava.'

The former Cobb's Bank. (Nick Barham)

2. Margate's Magnificent Squares

The creation of Cecil Square and Hawley Square in the late eighteenth century transformed Margate into an elegant resort. A few years before, it had been anything but.

When Daniel Defoe passed through in the 1720s, on his *Tour Through the Whole Island of Great Britain*, he was able to dismiss Margate in a line, saying 'the town of Margate is eminent for nothing that I know of.' Zechariah Cozens, in his *Tour through the Isle of Thanet*, said it was 'but a long dirty lane, consisting chiefly of malthouses, herring hangs and poor little cottages of fishermen'.

Cecil Square. (Nick Barham)

Hawley Square.
(Nick Barham)

Cecil Square

Cecil and Hawley squares became the heart of this newly transformed town. However, standing today in Cecil Square, packed with traffic, parked cars and buses at their stands, it is hard to imagine this place as it was in 1769, when royalty, the great and the good met and mingled in the Royal Hotel's assembly rooms, and resided in the once-elegant terraces that enclose it.

So let me help you. Stand with your back to the former post office, with the present-day library, magistrates' and county court to your left. Where the library is now, the Royal Hotel, with its assembly rooms, once stood.

Kidd's Pocket Companion describes it thus: 'The superstructure is of the Ionic order, embellished with large Venetian windows, with entablature and cornice.'

The hotel occupied the front of the building, which faced the square, its white wooden pillars extending over the roadway, with the main assembly room behind it. Joseph Hall, in *Hall's New Margate and Ramsgate Guide*, describes it as being 'finished with great taste and elegance, and supposed to be one of the largest in the kingdom. It is situated upon an eminence and commands an extensive prospect of the sea; it is eight-seven feet long, and forty-three broad, of a proportionable height, and richly ornamented'.

Kidd says: 'The entrance to the assembly room is at the west-end of the colonnade, from whence, by a long and lofty vestibule, we arrive at the stair-case, which conducts us to the card, tea, waiting, and ball or assembly room.'

It was opulently decorated, with mirrors, busts – including one of George III, another of the Duke of Cumberland – and five great chandeliers, which were later converted to run on gas and named 'gaseliers'. Balls were held twice a week during the season, with lunchtime

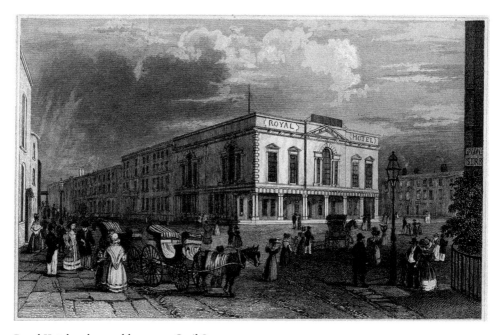

Royal Hotel and assembly rooms, Cecil Square.

music recitals and plays five days a week, and sacred music on Sundays. 'At the west end is a handsome elevated orchestra, which is reached by a communication without the room.'

According to the *Daily News*, the assembly room was 'well known as the once favourite resort of George IV' and that 'it was a cherished tradition of the place that the first gentleman in Europe had more than once danced a cotillion on its chalked floor'. No mention, once again, of George IV having met his future wife here. The season opened on 4 June, the birthday of the then king, George III, and ended in October.

Joseph Hall goes on: 'Adjoining to this room, are apartments for tea and cards, which are perfectly convenient; the ground floor consists of a good billiard and coffee room, which adjoin the hotel; and a large piazza extending the whole length of the building. The number of subscribers [regular, paying users] to these rooms amounts usually to above a thousand.'

DID YOU KNOW?
If you look closely at the former Post Office in Cecil Square, now a restaurant, you will spot a foothold cut into the stone at around knee height, with a grab-handle above it. There is also a small area of clear glass in the frosted panel above this point. Why? So that a policeman patrolling at night could hoist himself up and see that the safe was still intact.

Beyond the Royal Hotel and assembly rooms once stood another hotel, 'of equal excellence, and several good inns, where families may be genteelly accommodated until they have provided themselves with lodgings agreeable to their wishes'.

Now look to your right, where smart shops once stood. Some buildings have survived from 1769 – including the dentists' surgery at No. 1 – but the Baptist Church, formerly the Ebenezer Chapel, was built in 1899 as an extension of the chapel that stood behind it.

In *The Kentish Traveller's Companion*, Thomas Fisher says there were also: 'Some very handsome houses, built by persons of fortune for their own use, with several others intended for the reception of the nobility and gentry.' One such is ahead of you. Above what is now the NatWest bank, a blue plaque records that the Duke of Cumberland, George III's brother and the prince regent's uncle, lived here. There was also a circulating library on this side of the square.

The High Street, then bordering the sea, runs just behind the bank, and there were also upmarket bath houses on this far side of the square. Fisher says:

Besides the tavern in the square, there is the New Inn, kept by Mitchener, by the water-side; it is much frequented both as a good inn and tavern, and has a billiard-table and coffee room. Mitchener has also erected two new warm salt-water baths, on a most excellent construction, which are very elegant, and built at a great expense ... and may be brought to any degree of temperature required, with the utmost ease.

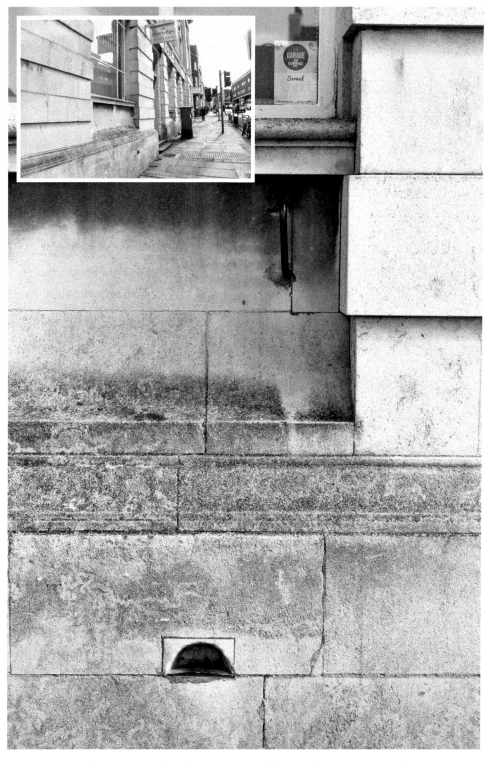

The former post office (inset) and the foothold and grab bar used by police on patrol. (Nick Barham)

Fisher notes approvingly that Cecil Square 'is paved in the same manner as the streets of London'. Matching London, in this and every other conceivable way, was the goal of this new, vibrant Margate.

William Kidd praises 'A company of public-spirited individuals [who have] rendered the town attractive, by the erection of fit dwellings for the noble and the rich; and the unrivalled superiority of Margate as a bathing retreat, coupled with the facilities of communication, afforded by the modern improvements in steam[ships], have given rise to its present importance.'

The aim of men such as Sir Henry Hawley – who gave his name to Margate's second great square – Dr Daniel Jarvis and Francis 'King' Cobb was to create a resort in which wealthy Londoners would feel at home, and which could equal the capital in terms of the quality of its architecture, its hotels and entertainments, its places of worship and lending libraries. It also needed to rival the sophistication of established spa towns such as Bath, and bathing resorts including Brighton and Weymouth.

> DID YOU KNOW?
> A Cecil Square publican had a dog trained in a particularly useful skill. *Kidd's Pocket Companion* of 1831 relates: 'The landlord of the tap belonging to the [Royal] Hotel is in possession of a dog, who is found useful in fetching home the pewter-pots whenever he sees them standing at the doors of his master's customers.'

The Duke of Cumberland's residence in Cecil Square. (Nick Barham)

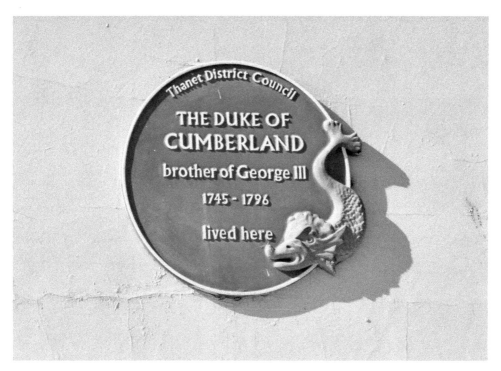

The blue plaque to Cumberland, the prince regent's uncle. (Nick Barham)

The north side of Cecil Square, dating from 1769, with the 1899 Baptist Church. (Nick Barham)

Hawley Square

Hawley Square was built a few years after Cecil Square, and on a grander scale. It took the then up-to-the-minute London model, being built around a spacious pleasure garden created for the enjoyment of its residents.

In 1800 the square comprised, says Nigel Baker in *Margate's Seaside Heritage*, 'an entire range of genteel houses from one end of it to the other, most of which command a fine and extensive prospect over the sea'. The houses were built between 1770 and 1790.

W. C. Oulton, in his *Picture of Margate, and its Vicinity* writes: 'Hawley Square, erected in a contiguous field ... is a uniform range of handsome houses. The range to the west is called Church Field. The pleasure ground to the centre of the square is a great ornament to the place, and an agreeable walk for children.'

Hawley Square has survived somewhat better than Cecil Square. If we stand on its south side and look downhill over the pleasure gardens, we see in the right-hand corner the Theatre Royal, built in 1787, which survives intact and is said to be the second-oldest theatre in the country.

Kidd's Pocket Companion describes a structure 'which is exteriorly a neat but unadorned brick building, after the model of old Covent Garden, having, however, its interior fitted up in a chaste and pleasing style, and its scenery painted in a bold and masterly manner'. The theatre gained its present stuccoed appearance in 1874.

Houses in Hawley Square. (Nick Barham)

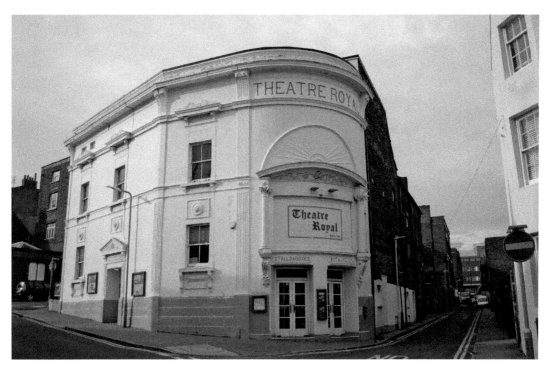

The Theatre Royal.

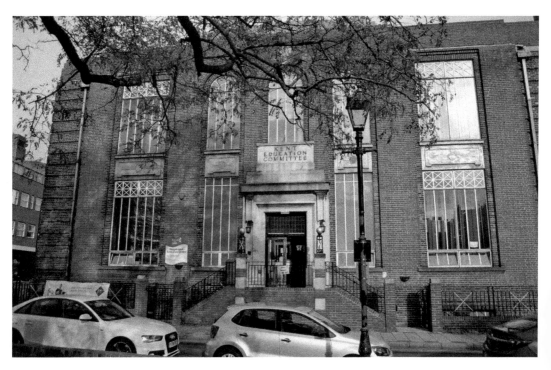

The art deco Thanet School of Art replaced Bettison's library.

In the left-hand corner of the square, and built in 1786, stood Hall's library, which became known as Bettison's library from 1800 until it was demolished in 1928. W. C. Oulton wrote of it:

> Bettison's library exceeds the Marine Library [in the High Street, and formerly the smartest in town] in point of size and magnificence. The entrance consists of a colonnade; which runs along two sides of the edifice; and the shop is separated from the library by a row of Corinthian columns. Over the shop is a capacious dome, eighteen feet in diameter and sixteen feet in perpendicular height above the ceiling; from the centre of which a superb cut-glass chandelier is suspended ... The whole interior of this extensive establishment is elegantly decorated with mirrors, busts &c.
>
> The room is generally filled with personages of rank and fashion ... There is an entertainment of vocal and instrumental music every evening: a young lady, only twelve years of age, sung last season with considerable taste and judgement.

The library was replaced, in 1928, by the art deco Thanet School of Art. In 1934, the British artist Walter Sickert (1860–1942) lectured there. The building now houses Margate Adult Education Centre.

In the centre of this side of the square is the rendered, white-painted Hawley Square Chapel, a Wesleyan Methodist church built in 1811. It was extended in 1896 in the French Gothic style, and has now been converted into flats.

The former Methodist Chapel, painted cream, in Hawley Square. (Nick Barham)

It is significant that a Nonconformist congregation established itself in a prominent place in Hawley Square as another, the Baptists, were about to do in Cecil Square. With the Church of England observance strong in this new Margate, these two sets of Nonconformists wanted to assert their right to a place at the town's social top table, but were anxious to make it clear that they did not intend to challenge the Established Church.

In *The Margate Guide*, a book attributed to 'An Inhabitant', it is stressed that the chapel exists 'not in opposition, but as an appendage, to the Established Church, of which the congregation are not only members, but constant attendants; as the service here is at intervening hours'. A poem is included, a plea for tolerance and acceptance of Nonconformism, which appears to have been written in response to sectarian undercurrents in the fashionable circles of the town:

HAWLEY SQUARE CHAPEL
In Hawley Square an humble temple stands,
Proof of the toleration in these lands –
Blest spirit! may thine influence ever move
Each heart to such benevolence and love.
Here, through thy kindness, gospel truths are taught;
And here the wonders of our God are wrought.
Though stigmatiz'd with those reproachful names,
By which Invective, Virtue oft defames;
Yet names are nought, 'tis nature only can
Bespeak the real actions of the man.
Then what avails it by what name I'm known:
This ne'er will come before th' Eternal's throne;
I there shall not be ask'd, where I believ'd,
Or in what name the sacred truth receiv'd:
Whether or Catholic, or Protestant,
Or Baptist, Methodist, or Recusant.
'Tis truth alone that by our God is priz'd,
Which by sincerity is realiz'd: –
Then, as at first, we still again declare,
That titles are but bubbles light as air.

The pleasure gardens, on gently sloping ground that falls away before us from south to north, were an impressive setting. What now is an open, grassy area was, in the original design, far more ambitious. The layout was distinctive. Whereas now the paths are laid out in a simple diamond, then there was an outer, circular path from which four serpentine walks gravitated towards the centre, where an oak was planted. This once-grand tree split in two in 1974 and, while one half remains, is something of a sorry specimen today.

Kent Gardens Trust, in a paper detailing what an asset this space is to Margate, notes that the land was only sold for development on the understanding that the pleasure garden would be created.

The pleasure gardens were an essential feature of Hawley Square. (Nick Barham)

The garden followed the latest in horticultural fashion. The trust's research reveals: 'the design bears marked similarities to a prototype design by the writer and horticulturalist, John Claudius Loudon (1783–1843) ... and appears to have been adopted in Hawley Square only a few years after the design was published.' An inner circular path was added, around the central oak tree. 'The layout also incorporates early eighteenth-century planting principles advocated by the nurseryman Thomas Fairchild (c. 1667–1729), who, according to a foremost authority on London squares, was the first to suggest that trees should be planted at the centre.'

The garden was greatly valued. Oulton's *Picture of Margate* notes: 'The pleasure ground ... preserved for the benefit of the inhabitants of that square, affords a place of safety to children from horses and carriages; is an advantage eagerly sought for by parents; and is besides a great ornament to this part of the town.' Oulton says that 'respectable visitors' were allowed admission for a small sum, in order to help pay for the installation of iron railings.

By the 1930s the gardens had suffered a period of neglect and, in 1934, a new design was imposed, introducing the diamond-pattern paths seen today.

Among the distinguished residents was, at No. 18 Hawley Square, Dr Daniel Jarvis (1766–1833). He is noteworthy for two reasons: as a philanthropist and as a driver of town development. As a postscript to a newspaper advertisement of January 1788, detailing his skills as an apothecary and practitioner of midwifery, Jarvis says: 'N.B. Will attend any poor woman gratis, within six miles, for four months from the date hereof.'

Jarvis did a great deal to help shape the new Margate. *Kidd's Pocket Companion* said of him: 'the prosperity of the town is mainly attributable to its numerous public buildings, which have been mostly projected by, and carried to a successful completion, through the indefatigable exertions and energetic conduct of Dr Jarvis.' He also created a piece of vital infrastructure that did more than any other to facilitate visits to the town, as we shall discover in Chapter 3.

The Conflagration

Why has Hawley Square survived so much better than Cecil Square? Because, on the night of 28 October 1882, Cecil Square was the scene of a ferocious fire, which became known as 'the Conflagration'.

Anthony Lee, in his *Margate in the Georgian Era* quotes the *South Eastern Gazette*'s report, under the headline 'Alarming Fire':

> On Saturday the most alarming fire ever known in Margate took place, but, fortunately, no lives were lost. The destruction of property is estimated at no less than £40,000 or £50,000, and there were entirely destroyed ... the Royal Hotel, the Royal Assembly Rooms, and spacious residences in Cecil Square ... being the whole of the south or top of the square.

The report says that Freemasons leaving their lodge opposite the Royal Hotel at around 11.30 smelled smoke coming from the assembly room 'supposed to have been caused by someone throwing a lighted fusee [a large, wind-proof match] on the floor ... The entire building was in flames in a very few minutes; it was composed, to a large extent, of lath and plaster, the outer walls shortly afterwards falling with a loud noise'.

The flames spread to buildings on either side, destroying a school and vicarage. Buildings were blown up to prevent the fire reaching the High Street. The fire was not under control until 10 a.m.

A theatre, The Grand, was built in place of the Royal Hotel, but did not thrive and, in 1905, it was renamed The Hippodrome and became a music hall, then later a cinema. It was demolished in 1966.

DID YOU KNOW?
The Theatre Royal is reputed to be the most haunted in the country. Apparitions include a ball of orange light; an invisible screaming entity that travels from the wings, across the stage and exits through the stage door; the ghost of a dismissed actor who committed suicide by throwing himself from a box into the orchestra pit; and Sarah Thorne, one-time theatre manager. Her angry spirit was first provoked in 1934 when the theatre became a cinema, and was renamed the Kinema Royal. She appeared once again when it briefly became a bingo hall.

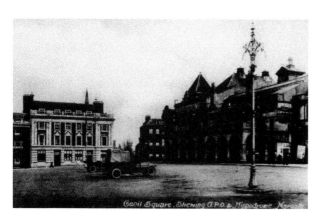

The Hippodrome, on the site of the Royal Hotel in Cecil Square.

3. Ships and Storms

The Margate Hoy

If you were to call 'Ship ahoy!' would you be asking for a trip to Margate? In the eighteenth century, you might well have been.

Before 1815, most visitors travelled from London in Margate hoys. These were single-masted sailing ships of between 60 and 100 tons that once carried goods between Thanet and the capital, but were converted to carry passengers when the tourist trade proved more lucrative. Hoys could be hailed at any of the many piers they passed on their way down the Thames from London.

Margate Harbour, *c.* 1897.

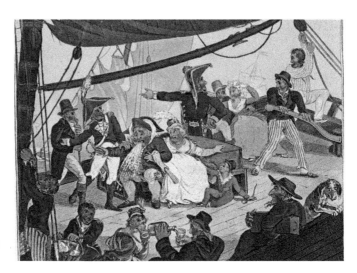

A scene onboard a Margate
hoy, by Dibdin.

The first example of the expression 'ahoy' can be attributed to a seaman in Tobias Smollet's *The Adventures of Peregrine Pickle* in 1751. In 1789, the composer Charles Dibdin included the word 'ahoy' in the lyrics of 'Sea Shanty', a song sung by able seamen in his musical *The Oddities*.

Dibdin seemed to be taken with the little ships, and in 1804 wrote a comic song called 'The Margate Hoy'. The song begins:

> Standing one summer's day on the Tower Slip,
> Careless how I my time should employ,
> It popp'd in my head that I'd take a trip
> Aboard of a Margate hoy.

The trip to Margate could be an arduous one. The vagaries of tides, winds and weather meant that the journey from London often took two days and nights, and the song goes on to chronicle, to comic effect, the privations and suffering of those onboard:

> And now 'twould have made a philosopher grin,
> To have seen such a concourse of muns [poor devils];
> Sick as death, wet as muck, from the heel to the chin,
> For it came on to blow great guns:
> Spoilt clothes, and provisions, now clogg'd up the way,
> In a dreary and boisterous night;
> While apparently dead every passenger lay
> With the sickness, but more with the fright.

Finally, the destination comes into view:

> At last, after turning on two or three tacks,
> Margate lights soon restor'd all our joy;
> The men found their stomachs, the women their clacks [chatter],
> Sing who so blyth as we,
> Who take a voyage to sea,
> Aboard of a Margate hoy.

Nigel Barker, in *Margate's Seaside Heritage*, explains: 'What made Margate unusual among the earliest resorts was that a substantial proportion, perhaps the majority, of its visitors arrived by sea.' Why? Because hoys were cheap. Barker reports: 'In the 1790s a single coach trip to Margate cost between 21s and 26s [from £1.05 to £1.30], while the cheapest hoy fare was only 5s [25p], allowing a lower class of visitor to travel to Margate.'

Charles Lamb, in *Essays of Elia*, records meeting a mixed crowd on his first hoy-trip to Margate:

> Not many rich, not many wise, or learned ... We were, I am afraid, a set of as unseasoned
> Londoners (let our enemies give it a worse name) as Aldermanbury [an area east of

St Paul's], or Watling-street, at that time of day could have supplied. There might be an exception or two among us, but I scorn to make any invidious distinctions among such a jolly, companionable ship's company, as those were whom I sailed with.

DID YOU KNOW?
The memorial statue at Nayland Rock to the coxswain of a Margate lifeboat, the *Friend of All Nations*, is a powerful symbol of the town's seafaring history. It commemorates the tragic loss of nine lives when the lifeboat – then known as a surf boat – capsized during a rescue in 1897. Behind this tragedy is the heroic story of how Margate came to have a life (or surf) boat. In 1850, 250 lives were lost when the *Royal Adelaide*, a Dublin steamer, was wrecked on Tongue Sands off Margate. This tragedy led seafarers to decide they must have a rescue ship.

The Steam Packet

In 1815 a regular steam packet service was introduced, cutting the journey time radically from up to two days to eight hours, and later to six and a half hours. Steamers were also larger and cheaper, meaning Margate was now within reach of many more and less-affluent people. In 1815, 22,000 arrived by sea; by 1835 the number had risen to 109,000.

The swift journeys meant that, in the summer, men would work in London during the week and join their families in Margate for the weekend, travelling on the 'Husbands' Boat'.

Whereas on the hoys accommodation was cramped and dirty, the steamers were, it was said, like being in a London coffee house, with music, cards, backgammon and chess.

In *The Early Kentish Seaside*, John Whyman relates the account of a passenger on board the Margate Steamship Company's packet, *Venus*:

Splendid cabins, mahogany fittings, horsehair sofas, carpeted floors, tiers of windows like the ports of a frigate, with bars and barmaids, kitchen and cooks, stewards and waiters and all the suitable paraphernalia of splendid breakfasting and dinnering administer their comforts to as easy, lounging genteel and amalgamated conglomeration of passengers as ever promenaded with measured steps to a band of musicians between the stem and stern of a vessel.

But not everyone welcomed the demise of the hoy. Charles Lamb lamented their passing, saying:

Can I forget thee, thou old Margate hoy, with thy weather-beaten, sun-burnt captain, and his rough accommodations – ill exchanged for the foppery and fresh-water niceness of the modern steam-packet? To the winds and waves thou committedst thy goodly freightage, and didst ask no aid of magic fumes, and spells, and boiling cauldrons. With

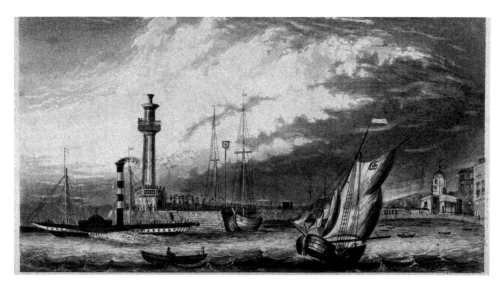

Margate Pier with wooden lighthouse and a steam packet. (Wellcome Collection)

the gales of heaven thou wentest swimmingly; or, when it was their pleasure, stoodest still with sailor-like patience. Thy course was natural, not forced, as in a hot-bed; nor didst thou go poisoning the breath of ocean with sulphureous smoke – a great sea-chimæra, chimneying and furnacing the deep.

DID YOU KNOW?
There used to be a much taller wooden lighthouse than the present concrete one at the end of the pier. It was destroyed in the terrible storms of 31 January and 1 February 1953, the worst to hit the South East in living memory. A combination of high tides and strong winds caused the lighthouse, a Doric column with a square gallery and cylindrical lantern, to lurch to a precarious angle before collapsing into the sea. The storms breached the sea wall in several places, and much of the old town was flooded.

The Various Classes of Visitor
In *The Land We Live In*, a book of essays published in 1848, we get a portrait of the sort of people now coming to Margate: 'That part of society which is called "fashionable", and which once frequented the place, have long deserted it, and almost entirely.'

Now, we learn:

The place is annually visited by tradespeople, varying in degrees of prosperity, or, as it is styled, 'respectability', by professional men and their families, and by not a few retired independent gentlefolk, who can be happy without being fashionable, and enjoy the

gaiety they see around them without marring the pleasure by sneering at fashions in dress, and fashions in manners not quite their own.

These various categories of visitor, it seems, were very conscious of their place in the hierarchy: 'The shop-keeper from Piccadilly or Oxford Street looks down upon the Cheapsider, the Cheapsider looks down upon the Whitechapeler, the Whitechapeler upon the Mile-Ender; and their respective spouses and daughters have a critical gamut about "spheres" and "fashions", and "good company" and "fit company", and so on.'

Of them all, our un-named correspondent much prefers the cockneys: 'The real genuine Cockneys ... are to be found in the lower part of the scale; and they are the merriest and happiest, and, in our estimation, the most interesting of the whole host. They come down to enjoy themselves, and they set about it with a zest and earnestness truly exemplary.'

So what did this merry crowd get up to? We learn:

The first thing they do, when landing from the steamer, is to sit in an open window and eat shrimps; the second thing is, to level a telescope or some sort of spy-glass at the broad sea; and the third thing is, to sally out and buy a pair of yellow or 'whitey-brown' Margate slippers, wherewith to trudge along the sands, and ascend the gaps or gates cut in the cliffs, and walk along-shore and over the chalky cliffs, whose soil is unfriendly to Day and Martin's blacking.

On the morning after their arrival, visitors would take to rowing boats, sailing dinghies, ride along the beach in donkey chaises or on the animals' backs. Ladies, it seems, relished borrowing popular novels from one of the numerous circulating libraries and reading them on the beach.

The cockneys seemed to believe that 'the more they eat at Margate, the more health they will carry back with them to smoky London'.

They would take trips to houses and gardens in the nearby countryside, including what was known to them as Dandelion, but is properly called Dent de Lion – the grounds of a medieval, fortified manor house where just the fifteenth-century gatehouse survived – for public breakfasts, bowls, music and dancing on the well-kept lawns.

Promenading was another pleasure, particularly along the clifftops at the fort, to the east of the town centre. The fort originally provided the main defence for Margate's harbour and for shipping navigating the North Foreland, but in the early nineteenth century a public walk was created there, designed to rival the Stein at Brighton and Weymouth's esplanade.

DID YOU KNOW?
There was once a huge visitor attraction in Margate of which there is now no trace. Marine Palace, with its aquarium, ballroom, skating rink, two swimming pools and billiard room, had been built in 1876 on reclaimed land, where once there had been a bay, at Rendezvous, close to the current Turner gallery. It was destroyed in a storm in 1897.

Dr Jarvis and the Great Storm of 1808

On the night of 14–15 January 1808, Margate suffered a terrible storm, during which much of its tourist infrastructure was destroyed. The *Kentish Chronicle* reported that the sea breached the pier, and that six ships moored in the harbour broke free and smashed against the stone wall protecting the esplanade, allowing the sea to flood the town. A 20-foot chasm rent the High Street, washing bathing houses and part of the King's Head (now Morgans) into the sea.

What was to be done? While rapid repairs were made, a further storm split the pier head in two. Radical action was needed. Cometh the hour, cometh the man.

Janet Robinson, in *A Branch of the Jarvis Family*, writes that Dr Daniel Jarvis, who we met in the previous chapter, developed an ambitious plan to build an entirely new stone pier. Parliament granted the town £5,000 but it was not enough, so Jarvis created a joint stock company to take ownership of the pier and harbour, fund the shortfall and do the building. In 1812 the Margate Pier and Harbour Company was formed, with Dr Jarvis its chairman.

Jarvis's company funded the work by charging 2s for every passenger arriving at the port, plus dues on goods loaded and unloaded. They also charged promenaders to walk on the pier.

However, there was a problem. The new, larger steam packets could only draw up to the pier at high tide. At other times, passengers had to transfer into smaller boats and be rowed ashore. Dr Jarvis's solution was to build a 1,120-foot wooden jetty next to the pier at

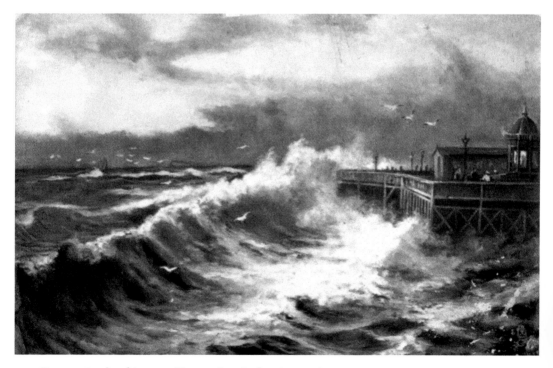

Storm waters breaking over Margate Jetty in the nineteenth century.

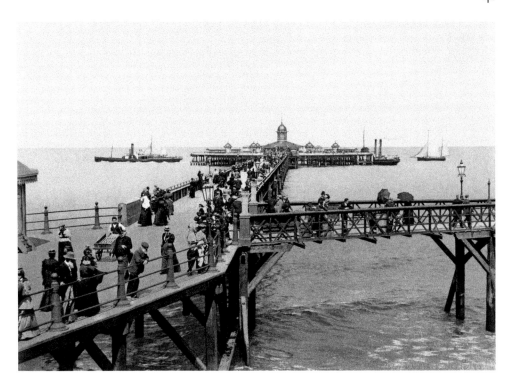

Above: Margate Jetty in 1897 with steam packets at the jetty extension.

Right: The concrete lighthouse on Margate Pier. (Nick Barham)

which mooring was possible whatever the state of the tide. It was named Jarvis' Landing Place. Unfortunately, there was another problem. The middle of the jetty was lower than the far end, which meant that it became submerged at high tide, and local boatmen were called upon to row passengers around the submerged section.

The money earned was not nearly as much as boatmen made before the construction of the jetty, when they ferried passengers to and from steam packets anchored out in the harbour. They burned an effigy of Jarvis at the entrance to the pier.

By 1850 the jetty had outlived its usefulness and a new one was commissioned. The new, iron Jarvis' Jetty opened in 1857, with a hexagonal pier head extension added two years later.

A further great storm, of 31 January and 1 February 1953, once again caused severe damage to Margate's tourism infrastructure. The storm caused devastation all along the coastline of south-east England. In Margate, it damaged Jarvis' Jetty and Cliftonville Lido, among many other places. Another catastrophic storm, in 1978, marked the final demise of the jetty, robbing Margate of what had been one of its most popular attractions.

DID YOU KNOW?
In the harsh winter of 1963 the sea froze at Margate. The bad weather had begun the previous Boxing Day, with 18 inches of snow falling on the North Kent coast and drifts of up to 8 feet. By January the sea had frozen up to a mile off shore, and fishing boats were trapped in the ice in Margate's harbour.

4. From Hall by the Sea to Dreamland

Hall by the Sea

A scruffy little street with an unusual name runs just behind the seafront arcades on Marine Drive. It is called Hall by the Sea Road, and its name is a throwback to a remarkable attraction, the forerunner of Dreamland, which spreads inland from this little road.

Until 1909, when a causeway and sea wall were built, the land where Dreamland now stands was a mere, or salt marsh. In 1866 the London, Chatham and Dover railway built a station on the site occupied today by the Dreamland Cinema, but no trains ever ran to it. The reason: the South Eastern Railway had got to Margate first, in 1846. Plans by the London, Chatham and Dover Railway to offer a local service to Broadstairs and Ramsgate came to nothing.

What to do with a railway terminus nobody wanted? The disused station buildings were taken over by Felix Spears and Christopher Pond, two pioneering railway caterers. With the contract to spread first-class cuisine throughout the London Chatham and Dover railway's network, they turned the unused station buildings on the mere causeway into a concert and dance hall that they named Hall by the Sea.

Spears and Pond had huge success elsewhere, later building and running the Criterion in London's Piccadilly Circus, but they couldn't work their magic in Margate. In 1870 the

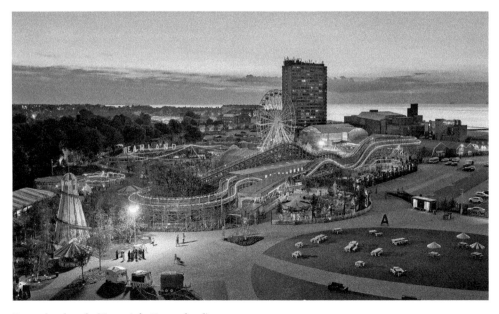

Dreamland park. (Copyright Dreamland)

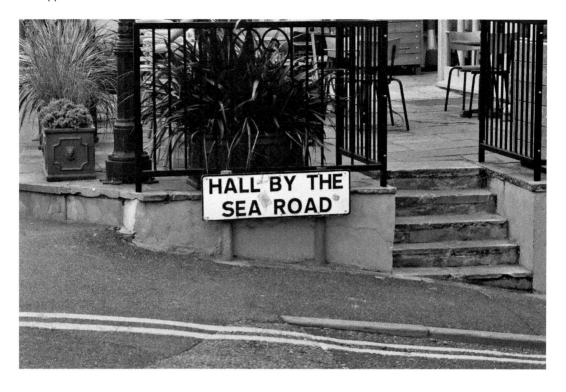

Above: This street sign is a rare reminder of Deamland's forerunner.

Left: Hall by the Sea Road.

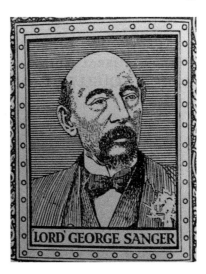

'Lord' George Sanger.

buildings were bought by the then mayor of Margate, Thomas Dalby Reeve, who went into partnership with a circus proprietor called 'Lord' George Sanger.

Sanger was not a lord, other than in his own imagination, but he was a remarkable showman. He performed for Queen Victoria at Sandringham in 1885 and Balmoral in 1898, and was the foremost circus owner of the Victorian period.

'Lord' George knew exactly how to gather a crowd and, when he came to write his autobiography, *Seventy Years a Showman*, he treated his readers just as he had the hundreds of thousands of Margate visitors who had poured into Hall by the Sea, writing: 'Walk up! Walk up! Walk up! This way for one of the most singular stories ever told by living man! This way for a tale of strange things, scenes, and adventures!' Even without the hyperbole, his is a great story, but with a disturbing and mysterious end.

Sanger's connection with Hall by the Sea began with a wedding. Thomas Dalby Reeve only met 'Lord' George because his daughter, Harriet, married Reeve's son, Arthur, in 1873. When Reeve Snr died, Sanger forged ahead with plans for the hall and the now-drained salt marsh and disused railway embankment behind it: he would create a remarkable pleasure and zoological garden.

In *Seventy Years a Showman* he writes: 'I went down to Margate, bought half-a-dozen bundles of wood, and pegged out the gardens and menagerie houses.' An advertisement announcing the grand opening of the resulting Italian and Zoological Gardens, in 1874, read:

Neither money, trouble, or taste has been spared in making these the most enjoyable Promenade by the Sea-side. The aid of Flora has been successfully invoked, and principal treasures in Trees, Shrubs, Plants, Flowers, and Statuary are represented. The Zoological Collection will comprise specimens of the most varied kind, and will constantly receive important additions of all kinds of birds and beasts ... The magnificent Hall has been considerably enlarged in such a manner as to meet the requirements of the largest quantity of visitors; whilst no expense has been spared in refitting and decorating in the most recherché and elegant style.

A handbill distributed in 1903 claimed: 'this mammoth establishment is the largest and most handsomely decorated and fitted place of entertainment out of London, and has accommodation for thousands.'

The spectacle began at the entrance, down Hall by the Sea Road, which turns to join Marine Drive between the Dreamland Cinema and the Cinque Ports pub. At what is now the entrance to Dreamland stood an arched gateway, which, Sanger claimed, was based on Margate Abbey. Never mind that Margate had never had an abbey. Later, more mock-Gothic ruins were built in the 16-acre grounds, and an animal house at the far end of the garden.

DID YOU KNOW?
The classic BBC TV comedy *Only Fools and Horses* 1989 Christmas special was filmed in Dreamland. The idea for the episode came from scriptwriter John Sullivan's sister-in-law Penny, who told him of an annual trip her father used to make to Margate with male friends and which he called 'The Jolly Boys' Outing' a phrase which was used as the title for the episode.

Above left: The former zookeeper's house. (Nick Barham)

Above right: Remnants of a now-listed lion's cage. (Nick Barham)

Within the walls of the supposedly ruined abbey lived an ever-increasing stock of animals, including twelve elephants, six lions, leopards, a Bengal tiger, six camels, horses, ponies, sixty monkeys, chimpanzees, hyenas, kangaroos, a bear, seals, wolves, alpacas and birds including cranes.

Today, the now Grade II listed remains of parts of the castellated stone and brick walls, inset with the iron bars of the lions' cages, can still be seen at the western edge of the site.

Sanger retired in 1905 to write his autobiography. Within a year of its publication in 1910 he was dead. There are various versions of how he met his end, but all agree that it was violent and at the hands of an employee, Herbert Cooper. Sanger was attacked with a cleaver by Cooper, who then committed suicide by throwing himself under a train.

The family insisted it was an unprovoked attack, but a report in *The Times* said that Sanger had sacked Cooper for stealing £50. In retaliation, Cooper picked up a razor used for veterinary work on the animals and cut the throat of a Sanger employee, then went for Sanger's grandson with a wood axe. When George Sanger rose from his chair to intervene, Cooper went for him with the axe. He was found on the floor, a large ornament broken beside him.

However, according to the Dictionary of National Biography, George Sanger was shot. His grandson, George Sanger Coleman, had some sympathy for Cooper and wrote in *The Sanger Story* that he believed his grandfather probably hit himself over the head when springing up, grabbing the large ornament as a weapon, and then overbalancing.

In death, Lord George was as big a draw as his creations had been in life. Special trains brought thousands of mourners to Margate. After a funeral at St John the Baptist he was

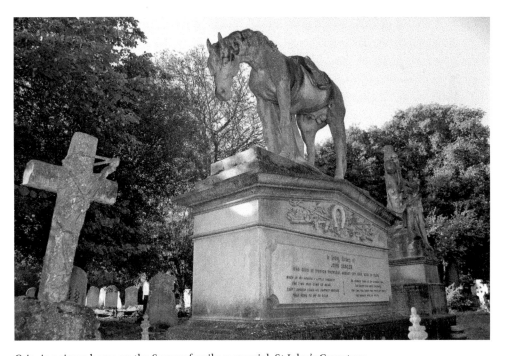

Grieving circus horse on the Sanger family memorial, St John's Cemetery.

buried in St John's cemetery, Manston Road, alongside his wife, the lion tamer Ellen Chapman, and other family members.

Sanger's remarkable family memorial features four marble statues of women on plinths in each corner, a marble angel placing a wreath on a ragged stone cross and, most poignant of all, a statue of a grieving circus horse, its head bowed, in honour of John Sanger, Lord George's brother. Sadly, while most of the inscriptions of those buried here are quite legible, 'Lord' George's is not. You can barely make out his name and the words 'The famous circus proprietor'.

The Man Who Gave Dreamland Its Name

The Hall by the Sea went into decline after Sanger's death, until rescued in 1919 by John Henry Iles and the showman C. C. Bartram.

Nick Laister, in *The Amusement Park: History, Culture and the Heritage of Pleasure*, says Iles was also passionate about brass bands, and during world tours with his band he had noticed the huge popularity of American amusement parks.

In 1906, Laister writes, 'during a visit to New York's Coney Island [Iles] obtained the European rights to the Scenic Railway roller-coaster. A year later he built the UK's first scenic railway at Blackpool Pleasure Beach,' plus others at London's White City and Earls Court. Iles set up amusement parks in Paris, Brussels, Petrograd, Cairo and Berlin but, according to Laister, 'Dreamland, the name Iles gave to his new Margate investment, was his first complete amusement park in the UK, opening in 1920 with its centrepiece Scenic Railway.'

Visitors, says Laister 'would have experienced modern and thrilling variations on the roundabout, such as the Caterpillar and Tumble Bug, traditional fairground rides such as the Helter Skelter and Gallopers, along with more elaborate permanent attractions such as the House of Nonsense, Miniature Railway, Zoo and River Caves, in which passengers were taken on a journey around the world in circular tubs that drifted sedately along an indoor waterway'.

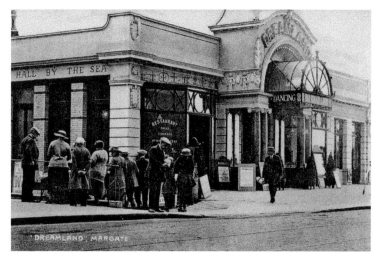

The original Hall by the Sea building bearing its new name: Dreamland.

The scenic railway before restoration.

Riding the restored scenic railway at Dreamland. (Nick Barham)

The Dreamland dream didn't last. Iles went bankrupt in 1938 and his son took over, but the park went into voluntary liquidation at the outbreak of the Second World War. Billy Butlin, of holiday camp fame, rescued it in 1946, and other owners followed during the 1980s and '90s. Jimmy Godden took over in 1995 and, while refurbishing it, removed many of the permanent rides. Fears for the survival of the Scenic Railway led to the formation of the Save Dreamland Campaign.

In 2001 Nick Laister succeeded in having the ride Grade II listed. He writes: 'It was a remarkable and rare survivor of a ride that was once common in the UK.'

That listing proved crucial in efforts to save Dreamland, because while the site could be closed – and was, in 2003 – the Scenic Railway could not be removed. In 2005 the site was sold to the Margate Town Centre Regeneration Company, which planned to build housing there. Arsonists attacked the Scenic Railway and it became a sorry version of its former glory, fuelling the campaign to save it.

Dreamland was compulsorily purchased by Thanet District Council in 2013, and reopened two years later as a combination of traditional seaside funfair and working museum of vintage rides. Sanger family members, including David Sanger, who leads the last horse-drawn circus show in the country, performed at the reopening ceremony.

Restored and reopened – Dreamland at night. (Copyright Dreamland)

Dreamland's renovated cinema. (Nick Barham)

It has not been plain sailing since. The company running Dreamland, Sands Heritage, went into administration for two years, but left it in November 2017.

New rides and an expanded list of entertainments, including the Screamland events around Halloween, have been added, as have a series of live music events in the original, 2,000-capacity Hall by the Sea auditorium behind the cinema, where The Who and the Rolling Stones once performed.

Restoration of the unique art deco Dreamland Cinema, which opened in 1935 with Greta Garbo in Painted Veil, was completed in 2017. With its huge fin tower, the cinema is a seafront landmark in Margate.

Whatever challenges Dreamland faces in the future, the name of 'Lord' George Sanger will live on: David Sanger and his partner Amanda Chapman named their son Lord Sanger after his illustrious forebear.

DID YOU KNOW?
Revd John George Wood, the nineteenth century's David Attenborough, gained his knowledge of animals and nature at Hall by the Sea and on Margate beach. He visited the town frequently because of his and his wife's ill health, studying animal behaviour on weekly trips to the hall's zoological gardens, and his 1857 book The Common Objects of the Sea Shore was informed by observations made on the beach.

5. Artists, Writers and Musicians

J. M. W. Turner

On the face of it, there aren't many secrets about J. M. W. Turner (1775–1851). His Margate connection is very well known. The Turner Contemporary gallery, built by the harbour at the very spot where he lodged, makes the link between Turner and Margate very clear and evident. Yet there is also a very powerful, personal story here that is little known.

Before we come to it, let's run quickly through what most people know about Turner in Margate. Most obviously, there is that gallery. Also, there is a blue plaque marking the spot, on the corner of Love Lane and Hawley Street, where he went to Coleman's school from the age of eleven.

Turner was sent away from his London home when his mother Mary began to suffer bouts of mental disturbance, first to Brentford, then a village, on the Thames to the west of London, and later – in around 1786 – to Margate. Turner was a child prodigy. He joined the Royal Academy of Art school in 1789 when he was fourteen, and had a picture accepted into the academy's Summer Exhibition at the age of fifteen.

He came back to Margate aged twenty-one, to sketch, and became a regular visitor from 1820 onwards.

It may have been on a steam packet taking him back to London from Margate that Turner got the inspiration for one of his best-known works, *The Fighting Temeraire*. As he passed Rotherhithe, the story goes, he glimpsed an old ninety-eight-gun warship being towed into Beatson's ship-breaking yard. HMS *Temeraire* had played a distinguished role in the British triumph at the Battle of Trafalgar in 1805, but now, in 1838, it was about to be broken up.

The view from the Turner Contemporary is the one the artist saw from his lodgings at Harbour House on Bank Side Quay. His landlady was Mrs Sophia Caroline Booth, soon to be widowed for a second time, and twenty years his junior. A relationship developed, which Turner chose to keep secret.

Turner came to Margate as much for Sophia as for the skies which, he told Ruskin, 'are the loveliest in all Europe' with their 'dawn clouds to the east and glorious sunsets to the west'. Today we know Mrs Booth's name, but very little else about her. Her powerful personal story deserves to be better known, and Sophia should be acknowledged not just as a footnote in a great man's life, but as the remarkable woman she was.

Turner and Mrs Booth lived together for eighteen years: the bulk of them in Margate, then from 1846 in a rented house in Cheyne Walk, Chelsea, where Turner assumed the name Admiral Booth.

One small clue in Margate hints at a tragic, little-known story about Sophia and suggests that there is much more to be discovered about her. That clue is on her gravestone in

Above: Turner Contemporary. (Benjamin Beker)

Right: J. M. W. Turner. (Courtesy of the Yale Center for British Art, Paul Mellon Collection)

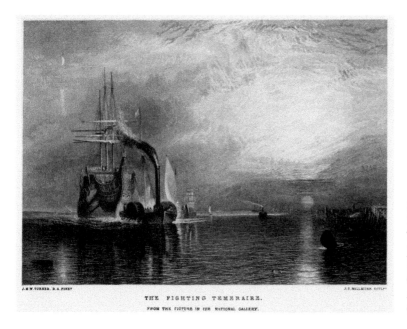

THE FIGHTING TEMERAIRE.
FROM THE PICTURE IN THE NATIONAL GALLERY.

The Fighting Temeraire, James T. Willmore after J. M. W. Turner. (Courtesy of the Yale Center for British Art, Paul Mellon Collection)

Antony Gormley's *Another Time* before the Turner Contemporary. (Stephen White)

St John the Baptist Church at the southern end of Margate High Street, a church that Turner had sketched as a schoolboy.

While Turner is buried in St Paul's Cathedral, Sophia's name, almost completely obliterated by time, appears at the very bottom of a gravestone headed by the name of her son, John Pound Booth: 'The beloved and only son of John and Sophia Caroline Booth, who died June 26th 1832 in the [and here the figure is obliterated by time] year of his age.'

Right: Sophia Booth's grave at St John the Baptist. (Nick Barham)

Below: Sophia Booth's name is almost obscured. (Nick Barham)

OPHIA CAROLINA BOOTH
RELICT OF THE ABOVE NAMED JOHN BOOTH
DIED JUNE 15TH 1878 AGED 80 YEAR

If that figure were legible, it would record that John Pound Booth was only six when he died of cholera, which swept the town that year and may also have infected his mother. His death was not the first tragedy to scar the life of Sophia Booth, as Franny Moyle reveals in *The Extraordinary Life and Momentous Times of J. M. W. Turner*.

Sophia was born Sophia Nollte, to parents of German immigrant descent, in Dover in 1799. She married her first husband, a nineteen-year-old Margate fisherman called Henry Pound, at St John the Baptist Church on 3 February 1818. She was twenty-two, and had, says Moyle, 'little education and a soft Kentish accent'. They had two sons – Joseph Henry and Daniel. This marriage was to prove tragically short. In the early hours of 22 March 1821, Henry Pound and his brother set out in the *Queen Galley*, a small fishing boat, with five others.

It was a scene that would have been familiar to Turner, who in *Fishermen at Sea* depicted just such a departure, the men rowing out to sea under the moonlight. Returning that afternoon in rough weather, the boat was caught on the treacherous Margate Sands and broke up. All lives were lost.

The tragedy left seven young children fatherless, and the *Kentish Gazette* published an appeal for charitable donations 'with a view to alleviating the distress of the surviving relatives which in several respects is very great'.

Three years later, the widowed Sophia suffered a further tragedy when her five-year-old son Joseph died. Widowed and again bereaved, Sophia struggled to cope. Little wonder, then, that only the next year she married the much older John Booth, who described himself as a gentleman of Margate. She was twenty-six, he was sixty-three. Within a year they had a son, John Pound Booth, whose tragic end is recorded at the top of the gravestone described above. Deeply concerned for his wife's health, John Booth amended his will, leaving the substantial sum intended for his now-dead son to her, saying that this was 'in consideration for the bad state of my wife Sophia Caroline Booth's health and in consequence of the lamented death of my son John Pound Booth'.

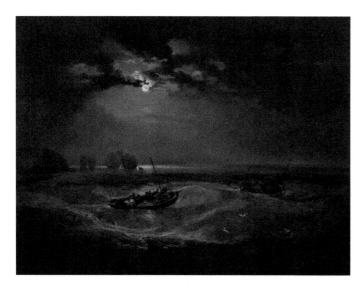

J. M. W. Turner's
Fishermen at Sea.
(Tate Britain)

When Sophia and Turner met, she was living with her elderly second husband at Harbour House. When Mr Booth died, Sophia was only thirty-four, but already twice widowed and still mourning the loss of two sons. Turner was also recently bereaved: still deeply affected by the loss, in 1829, of his father William, to whom he was enormously close. William had worked as his son's studio assistant for thirty years, and Turner suffered bouts of depression following his passing.

Turner would travel down on the so-called 'Husbands' Boat', used by the men of London at the weekends to join their families who were staying, or living, in the healthier air of Margate.

He clearly adored Sophia, wrote her love poems and gave her sketches, but did he ever paint her? The Tate has a work described as *A Sleeping Woman* that is perhaps Mrs Booth, and Ian Warrell, author of *J. M. W. Turner*, has suggested that 'some of the erotic sketches of Turner's last twenty years were stimulated by his intimacy with Mrs Booth'.

The relationship seems to have suited them both very well. Sophia was financially independent and undemanding, and Turner was almost entirely wrapped up in his art. Sophia seems to have stepped into the emotionally and practically supportive role previously filled by Turner's father. She died twenty-seven years after the artist, who succumbed to cholera in 1851.

The Shell Lady – Anne Carrington's tribute to Sophia Booth. (Nick Barham)

The Shell Lady looking out over Margate Harbour. (Nick Barham)

Sophia does have a public tribute in Margate. At the far end of the harbour wall is a modern sculpture of a shell lady entitled *Mrs Booth*. The 12-foot bronze was created by Anne Carrington, who says of it: 'The sculpture is a scaled-up version of the tiny shell lady ornaments which are sold in the souvenir shops on Margate sea front. What I like about this sculpture is its unlikely size and setting as the shell lady is granted all the civic respect of a local hero.'

DID YOU KNOW?
The Turner Contemporary was originally planned as a drum-shaped structure built on the seabed off the stone pier. Concerns were raised at the wisdom of exposing priceless art to the elements, in a spot where previous storms had wreaked havoc down the centuries. When a steel obelisk, built to test the feasibility of the plan, was swept away after two days in the water, it was decided to build the gallery on dry land.

Tracey Emin

If J. M. W. Turner is the artist most associated with Margate's first golden age, in the eighteenth and nineteenth centuries, Tracey Emin is the face of its renaissance, in the twenty-first.

Between them, their names have done a great deal to spur Margate's revival. From 2011 the Turner Contemporary has been drawing in an enormous number of visitors. In 2018 Tracey Emin set about creating her own gallery in the town where she was born, in 1963. Emin, together with the London gallery-owner Carl Freedman and businessman Jonathan Viner, has renovated the old Thanet Press building between Union Crescent and Princes

Street, close to Hawley and Cecil Squares, creating a vast gallery and studio complex, plus apartments.

She told the *Isle of Thanet News*: 'Margate has real energy and fantastic architecture, sunsets and seascapes and beaches ... I do not want to wake up to London, I want to wake up and be inspired by the same things that inspired Turner.'

Margate, and Emin's memories of it, feature heavily in her work. Emin's first quilt, *Hotel International: The Perfect Place to Grow* is named after the Margate hotel once owned by her father, and where she spent her early years. In her text work, *Exploration of the Soul*, Emin describes the idyllic early years she and her twin brother Paul spent at what she calls 'the giant hotel' before her father went bankrupt and left the family, returning to Cyprus.

The hotel, on the seafront overlooking the Winter Gardens, has now been divided into a number of smaller units.

A Margate sunset, loved by both Turner and Emin. (Nick Barham)

Tracey Emin (right) at Turner Contemporary's launch, with director Victoria Pomery. (Chris Laurens/Alamy)

In her memoir of Margate, *Strangeland*, Emin describes Hotel International as a seventy-room maze: 'It was actually six small guest-houses joined together full of strangers, guests, kitchen staff and chambermaids, a juke-box and the Blue Room, where we used to dance. We were rich and spoilt and spoke three languages: English, Turkish and, of course, our own.'

She and Paul played in the six backyards, joined by smashing holes in the separating walls, and had a language of their own until they were five. When her father, Enver, went bankrupt, the hotel was boarded up, and they dragged their furniture across the yard to a cottage at the back – the old staff house. The hotel remained empty and abandoned for years, but three squatters got in, who Tracey befriended. No one else knew they were there and she kept their secret. After her father left the family, they were so poor that Tracey's mother, Pam, took lead off the roof and sold it to buy food.

Like Turner, Emin was inspired by the town: 'The Margate of my mind has the most beautiful sunsets that stretch across the entire horizon. Sharp white cliffs divide a charcoal blue sea from the hard reality of the land.' The stretch of coastland in front of the old Hotel International, including the Winter Gardens and the Cliftonville Lido, holds what are clearly highly significant memories for her.

In *Strangeland* she writes of dancing on stage with Chuck Berry at the Winter Gardens, which, she says, 'sounds like the name of a romantic Victorian graveyard'. In her introduction to Janet Smith's book *Liquid Assets*, Emin shares her memories of the Lido, built in the 1920s by Dreamland's creator John Henry Iles over the old Clifton Baths, discussed in Chapter 1, and its huge open-air pool:

> It made Margate seem like the Mediterranean. Not like an English seaside town but somehow incredibly glamorous. It had a diving board that made me think of Elvis Presley. The pool was shaped like a half circle, with a curved tier of seats overlooking the water, like a theatre. They used to hold all these competitions. And there was a giant inflatable ball in the middle which me and my friends could roll over and around all day.

The pool was filled with sand in the 1980s.

Another significant Margate landmark for Tracey Emin is the Walpole Bay Hotel, where two of her works are on display. The hotel, which stands at right-angles to the seafront, just to the east of the old Hotel International, contains what its owner, Jane Bishop, describes as a living museum. All the public areas are filled with memorabilia from the Hotel's Edwardian past. Tracey Emin opened the museum in 2001, and her association with it dates to 1995, when she brought her mother here for a cream tea on the veranda.

In the restaurant is the Napery Gallery, containing works by Tracey Emin as well as approaching 200 other artists and visitors. The Napery is so named because all the works are drawn or painted on white linen napkins. The collection began by chance in 2009 when the writer and illustrator Curtis Tappenden asked for a linen napkin and drew a sketch of guests in the bar and restaurant. Drawing on napkins became a tradition, and they are framed along the walls of the restaurant.

 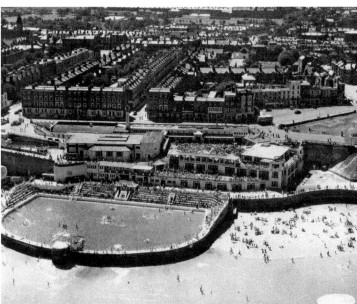

Above left: Cliftonville Lido's art deco beacon.

Above right: The Lido in its prime. (Aero Pictorial)

The Lido bathing pool today, filled with sand. (Nick Barham)

The Walpole Bay Hotel.
(Nick Barham)

The Napery at the Walpole Bay
Hotel. (Nick Barham)

Sketch on a linen napkin by
Tracey Emin. (Nick Barham)

The gallery got its name when a local, Stuart Atkinson, asked to see 'The Napery'. Jane had never heard the word before, and was calling the collection the Napkin Gallery, but Stuart told her that 'napery' was the collective noun for linen, and the name stuck.

One of Tracey's napkins is a portrait of Jane Bishop with the words 'The Banshee of Margate'. Jane says it is 'certainly causing a talking point' and she jokingly wonders how she is going to live up to her new name. The second napkin is a characteristic Emin scrawl that reads, in part, 'I love the Walpole Bay because it kept me happy for so long in my life.'

DID YOU KNOW?
A blue plaque on No. 25 Trinity Square states that Hattie Jacques and husband John Le Mesurier, of *Dad's Army* fame, lived here in the 1960s. However, in his autobiography, *A Charmed Rock 'n' Roll Life*, their guitarist son Robin Le Mesurier says they never lived there. Rather, it was occupied by his maternal grandmother, Mary. Hattie had bought the house for her and, says Robin, 'both Jake [his brother] and I would be packed off there for holidays whilst Mum and Dad were working.' He adds: 'Mary used to tell us ... there was stolen treasure somewhere in the house!'

David Bowie and The Lower Third

David Bowie's grandparents Margaret and Jimmy Burns lived in Margate, and he spent a lot of time here as he was growing up. In 1965 he joined a Margate group, The Lower Third, and released singles and toured with them.

He told Lesley-Anne Jones, author of *Hero: David Bowie*, that his grandparents were married in 1912 at All Saints Church in the Westbrook area of Margate, and that his grandmother, known as Peggy (née Heaton), was a nursing auxiliary at the Royal Sea Bathing Hospital.

He said of the town: 'Margate! I'm very fond of down-there. Maybe I'll move there one day. It'd be a great place to bring up kids. I do feel an affinity. I have a real fondness for the old seaside schtick, all that music-hall, end-of-pier stuff.' Bowie told Jones that he loved Dreamland, the Winter Gardens, and the Shell Grotto, which we shall explore in Chapter 6. Of his grandmother, he said: 'She used to sing me little ditties. One of them was about Margate: "A breeze! A breeze! Who sails today the ocean's swelling waters".' The lyrics come from 'Song of the Margate Boatman'.

In 1965, The Lower Third, were auditioning for a new lead singer, and among those who applied were an eighteen-year-old from Bromley called Davey Jones, and Steve Marriott, who would gain fame with The Small Faces. Davey Jones, who later changed his name to David Bowie, got the job.

In an article in *Rolling Stone*, Jordan Runtagh says the future David Bowie auditioned by belting out Little Richard's 'Rip It Up' and The Yardbirds' 'I Wish you Would', adding solos on his saxophone. The Lower Third's guitarist Denis Taylor later said, 'We liked the stuff he was doing, and he really started to develop an image for us, as well.'

The band, which also included drummer Les Mighall and bassist Graham Rivens, got a recording contract and released two singles, 'You've Got a Habit of Leaving Me' and 'Can't Help Thinking About Me', but neither made the charts. The second single is hugely significant for another reason, however: on the label it is credited to David Bowie and The Lower Third, the first use of the soon-to-be-famous Bowie name.

A lack of success and money troubles led the band to split in spring 1966.

John Keats

The one poet almost everyone can associate with Margate is T. S. Eliot. It is well known that in the winter of 1921–22 Eliot stayed with his wife Vivienne at the Albemarle Hotel in Cliftonville while both were recovering from nervous disorders. He walked to the Nayland Rock seafront shelter, now Grade II listed with a blue plaque in his honour, where he wrote part of *The Waste Land*.

Other famous writers have lesser-known links with the town. The romantic poet John Keats dedicated himself to a literary career while in Margate. Keats (1795–1821) was training as a doctor, but found himself increasingly drawn to life as a poet. He visited Margate in the summer of 1816 in order to write, staying in Hawley Square.

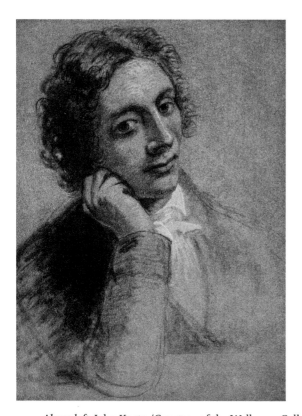

Above left: John Keats. (Courtesy of the Wellcome Collection)

Above right: The Northern Belle, where Keats stayed.

He came again the following summer, where local legend is that he stayed at The Northern Belle pub, writing his way through an opium binge on his epic poem *Endymion*, the opening line of which: 'A thing of beauty is a joy for ever,' has entered the language. It has been quoted by, among others, Mary Poppins, when she pulls a potted plant out of her carpet bag in the 1964 Disney film, and Willy Wonka in *Willy Wonka and the Chocolate Factory* referring to his Wonkamobile.

The Northern Belle, in Mansion Street, was named after an American ship that sank just off the Margate coast in 1857. Dating from 1680, it is Margate's oldest pub.

William Makepeace Thackery

The author best known for the classic 1848 novel *Vanity Fair* brought his wife, Isabella, to Margate on convalescent visits he could not afford, hoping that the sun and sea air might alleviate her debilitating depression. Sadly it didn't work, and Isabella made the first of several suicide attempts while here.

Vanity Fair, a satire on British society featuring the character Becky Sharp, is set during and after the Napoleonic Wars, and Margate gets a mention. Thackery writes: 'Margate packets were sailing every day, filled with men of fashion and ladies of note, on their way to Brussels and Ghent. People were going not so much to a war as to a fashionable tour.'

Thackery set several lesser-known novels in Margate. In *A Shabby Genteel Story*, well-born but impoverished George Brandon hides from his creditors in out-of-season Margate. In a satire on some of the chancers encountered in the town, Brandon takes cheap lodgings with the family of a bankrupted small businessman, yet pretends to be an aristocratic playboy.

Thackery writes that Brandon would 'spend his last guinea for a sensual gratification; would borrow from his neediest friend; had no kind of conscience or remorse left, but believed himself to be a good-natured, devil-may-care fellow'.

Pete Doherty and The Libertines

In 2017, Pete Doherty and his band The Libertines bought the rundown Palm Court Hotel on the Eastern Esplanade, which was one of the worst in the country according to TripAdvisor – 57 per cent of guests rated it as terrible. The band renamed it The Albion Rooms and transformed it into a stylish hotel and recording studios, plus a bar and café called the Harpo Club, a play on the Groucho, the London media members' club named after the eldest of the Marx brothers – Harpo being his younger sibling.

Since moving to the town from London, the band have become part of the community, playing regularly at venues, including the Tom Thumb theatre, and sponsoring the shirts of Margate Football Club, who play in the Bostik Premier League.

Doherty is a regular feature of Margate, playing impromptu gigs in shops and pubs and hitting the headlines when he managed to eat an enormous 4,000 calorie Megga breakfast at the Dalby Café in under twenty minutes, the first person to do so in five years.

Pete Doherty. (Courtesy of wobble-san under Creative Commons)

Eric Morecambe

The comedian, who was one half of Morecambe and Wise and who died in 1984, married Margate girl Joan Bartlett in 1952. Joan was a former Miss Margate whose family ran the Bull's Head in Market Square, and the couple held their wedding reception in the pub's upstairs function room, after which Eric immediately returned to London to perform on stage.

Joan told morecambeandwise.com, 'My brother [Harold] had come out of the war without a job, as many did, and my parents put up the money so he could go into the pub and restaurant business. He bought [the Bull's Head] a pub in Margate and they held the Miss Margate contest [in the town]. I entered and won. The prize was a modelling course at Lucy Clayton.' Joan then toured with variety shows, as a glamorous assistant to the acts, where she met Eric. She says:

There was nothing between us at first, just normal touring people helping each other out. He was due to play Margate and I was going to Morecambe [where Eric was from]. He said that I should stay with his parents and I told him to stay with mine.

The only problem was, when he turned up at my parents' pub he brought half of Billy Cotton's Band Show with him! Somehow they all managed to fit in.

DID YOU KNOW?
Dennis Wheatley, one of the world's most successful authors from the 1930s to the '60s, had fond memories of Margate. This master of the occult (1897–1977) enjoyed an idyllic childhood as a boarder at Skelsmergh House School, No. 33 Dalby Square. He often spent school holidays at his grandparents' house, Springfield in Hengist Road, between Westgate and Birchington. His grandfather knew the head keeper at the Hall by the Sea, and Dennis loved to visit the menagerie, where he was allowed to pick up lion cubs.

6. The Mysteries of Margate's Caves and Grottos

Margate is built on chalk, and chalk is an ideal medium for tunnelling: soft enough to cut through by hand, porous enough to avoid waterlogging, and resilient enough to retain its structure and integrity after sustained use.

No wonder, then, that there are numerous caves, caverns and passageways to be found beneath the town. Many were created for mundane purposes: to extract chalk to fertilise farmland, a process known as marling; or as an essential additive in brickmaking, giving the distinctive yellow colour to stock bricks that were so popular in Victorian times. Many other caves and tunnels were cut to facilitate smuggling. Three Margate caves are worth a closer look.

The Shell Grotto

On 22 May 1838 the *Kentish Gazette* ran a story about a mysterious underground structure, recently discovered in the garden of Belle Vue Cottage in Dane Road, Margate. Workmen digging in the garden had struck a stone slab with a spade. When the slab was lifted, a narrow circular hole was revealed. The hole proved to be at the apex of a square room

The Shell Grotto. (Nick Barham)

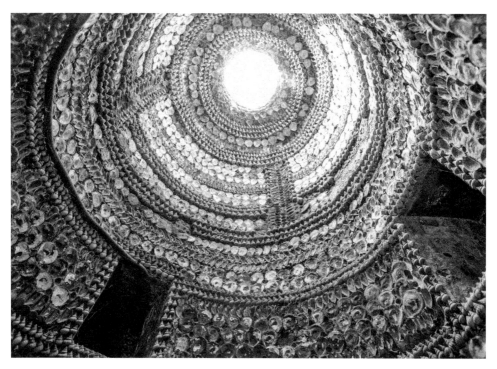

The Shell Grotto's domed main chamber. (Alamy)

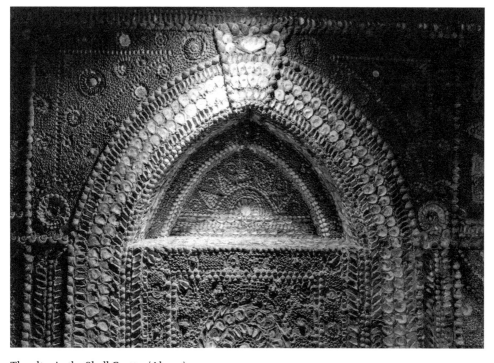

The altar in the Shell Grotto. (Alamy)

with a domed ceiling. Every inch of the room was covered with intricate patterns created from literally millions of tiny shells: cockles, mussels, limpets, scallops, oysters, winkles and whelks, which had been pressed into wet mortar.

A serpentine passageway led off this room to a point where the way parted. From here, two passageways, similarly decorated, formed semicircles before meeting again, and leading to a final serpentine passage.

The discovery threw up many questions. What was this place? When was it made? Who by? Why? How? Today, over 180 years later, we are little closer to answering those questions definitively. Was the grotto built by the Phoenicians sometime during the 500 years before the birth of Christ? Could it have been a Roman temple to Mithras? Was it Tudor, or created by members of the Knights Templar? Perhaps it was just a nineteenth-century folly.

Patricia Jane Marsh, in *The Enigma of the Margate Shell Grotto*, goes through the various theories and concludes that 'there are substantial grounds to suppose a Phoenician origin'. She notes that the Phoenicians, who hailed from present-day Lebanon, used the Isle of Thanet as a trading post when shipping tin from Cornwall to the Continent. In the Phoenician colony of Cadiz in southern Spain, on an island similar to Thanet, there was an oracle cave, offering a parallel with the Shell Grotto. It is possible, Marsh adds, that the name 'Thanet' came from the Phoenician goddess Tanit. However, she adds, 'there has clearly been intervention in the site, probably during the 1820s to the late 1830s, and some of the decoration dates from that period.'

One sure way to solve the mystery of Margate's Shell Grotto would be to carbon date the shells. That has not been done because of the prohibitive cost.

DID YOU KNOW?
David Bowie was fascinated by the Shell Grotto. He told Lesley-Anne Jones, author of *Hero: David Bowie*, that he could barely believe what he had seen there: 'So many shells, such intricate patterns, for no explicable reason: it was amazing. The maritime equivalent of Stonehenge.' Jones believes that the star on the west wall of the altar chamber may have stuck in Bowie's memory and inspired the title and cover artwork of his final LP, *Blackstar*.

Margate's Other, Secret Grotto

Thirty years before the discovery of the Shell Grotto, another mysterious shell-decorated cavern was discovered beneath Margate. It was under a building that became known as Mrs Hill's Grotto House. In the nineteenth century this cave was as popular with visitors as the Shell Grotto has remained since its discovery, yet today the Grotto House is almost completely forgotten.

On 26 September 1804 *The Times* carried a report of a discovery made during building works in the cellar of a house in a courtyard off the western side of Margate High Street.

The former Grotto House viewed from the High Street. (Nick Barham)

Mrs Hill's Grotto House viewed from Albert Terrace.

The house, accessed down the passageway between what are now Barclays Bank and the Premier food store, looked out across the harbour.

In the years since, many have confused this grotto with the far better-known one described above. In fact, they are a mile apart and very different. *The Times*'s report ran:

> There is at Margate, although known to only a very few persons, a curious grotto, concerning the construction and real date of which nothing is certainly known. It is on the premises and behind the house of Mr Oldfield, and has a door which opens towards the sea, behind which is another, glazed with painted glass, on which are various well-executed emblematical representations, with two armorial bearings, and an inscription with the name of a Dutch lady and the date of 1612. Whether this is the date of its erection or not cannot precisely be told. The place is quadrangular, with a sort of wagon roof, and most plentifully adorned with valuable shells of various kinds and sizes. It is floored in compartments with smooth stones and the spaces in between filled with pebbles. In one corner is an antique earthenware vessel, seemingly intended for the holding of Holy Water, a conjecture which receives confirmation on the east side which appears to have been formed to represent an altar piece. There is, therefore, little or no doubt that this apartment was originally calculated for the most austere and sublime exercise of the Catholic Church, admitting no light but through the small stained window, which however, when opened, immediately discloses a view of the ocean. It is only within a short time that it has been discovered. Nobody knows, as far back as is recollected what the place contained: but it is said that it was the burial place of some old person who had once kept the house.

The report raises some interesting questions. If this cave or cellar were for the celebration of Catholic Mass, it would have had to be hidden. It was not until 1829 and the Roman Catholic Relief Act that the restrictions on Catholic worship in England, in force since Henry VIII's time, were removed. Until then, there were constraints on Catholic worship and severe penalties for those caught practising the faith. So, unless the cave dated from before 1534, when the Act of Supremacy stated that the English Crown was 'the only supreme head on earth of the Church in England' in place of the pope, it would have been extremely dangerous to have such a thing beneath your house.

Richard Lewis, in his recent book *Discovering More Artistic Thanet*, notes that Mrs Hill was Catholic, and writes that she had installed the grotto as a private place of worship.

Little more is known about the origins of the Grotto House, but we can piece together some information about it, and its occupants.

Although it became known as Mrs Hill's Grotto House – Mrs Hill being owner of this and the adjacent Garden House – it was actually occupied by Mr and Mrs Thomas Oldfield. Mr Oldfield was a distinguished political historian, author of the *History of the Original Constitution of Parliaments* (1797). His wife ran a girls' boarding school, which had transferred to these premises from Hawley Square in 1801.

Mrs Hill, their landlady, was an interesting character, according to a local historian, Dr Arthur Rowe, who claimed: 'She was a lady of means (and easy virtue), and her title to

fame rests on the fact that she invited the rising young painter, George Morland, to stay with her in 1784.'

Rowe drew a series of maps, annotated with the names of all those who occupied premises in the town centre in a given year. On his map illustrating 1840, he wrote beside the location of the Grotto House: 'Way formerly leading to "Grotto House" High Street, the property of Mrs Hill', which could be read as suggesting that the house was no longer standing, or that access was now only from the seaward side.

In a letter accompanying the maps, now held in Margate Library, Rowe adds a clarifying note: 'Mrs Hill's house was in what is now known as Albert Terrace, a name dating only from 1868 ... The house was always given as in High-street, and was reached through the still existing opening opposite Bobby's Library. There was then a wall closing the opening, with wide gates therein, and this was the entrance to her house.'

What of Mrs Hill's Grotto House now? These days, while the entrance from the High Street still leads to the back of the house, its front door is on the other side, at No. 7 Albert Terrace. The house is much altered, and converted into flats. Rod LeGear, in his *Underground Thanet*, writes: 'At some time after [the grotto's] discovery the shell panels were removed and the site became a simple barrel-vaulted cellar extension. The house is still standing but has been renamed. It is still possible to discern the outline of the small window described [in the Times report], although it has now been rendered over.' Sadly there is nothing else to remind us of this second, mysterious shell grotto.

DID YOU KNOW?
Lewis Carroll visited the Shell Grotto during a five-week stay in the town in the summer of 1870. He went with a family he had befriended in the gardens at The Fort, and wrote in his journal: 'The day before we left I took Mrs Bremer and children to see the grotto (a marvellous subterranean chamber, lined with elaborate shell-work, supposed to be three hundred years old).' During the same stay he wrote to a friend, who was unwell: 'I am very sorry your neck is no better, and I wish they would take you to Margate: Margate air will make *any* body well of *any* thing.'

Margate Caves or Vortigern's Cavern

Margate Caves, once known as Vortigern's Cavern, are at No. 1 Northdown Road, and reopened to the public in 2019 after being closed on safety grounds in 2004. A campaign by the local community led to National Lottery funding of around £1.5 million, which brought them back to life.

The caves are believed to have originated as a chalk quarry dug in the late seventeenth or early eighteenth century. The caves were discovered in the late eighteenth century when, the story goes, a gardener digging in the grounds of Northumberland House fell through a hole into the cavern.

The owner of the house, Francis Forster, had various scenes painted on the walls, including a portrait of George III, and used the caves to store ice and wine. The paintings survive today.

The caves were sealed in 1835, when Forster died, but reopened briefly in 1863 when they were described as 'Vortigern's Cavern'. Vortigern was a fifth-century English ruler who reputedly invited Hengist and Horsa to help him fight off the Picts and Scots. However, they betrayed him, killed his son, and set up the Kingdom of Kent.

The caves were used as air-raid shelters during the First and Second World Wars, but in 1941 Nothumberland House, which had become the vicarage to Holy Trinity Church, was bombed along with the church, and both buildings razed.

During the restoration works that saw the caves reopen, an Iron Age burial was discovered on the site. This was a crouch burial, where the body is laid as if curled up and sleeping, and it had been placed in the bottom of a bell-shaped pit dug into the chalk.

DID YOU KNOW?
The first known record by a visitor to the Shell Grotto is a diary entry by nineteen-year-old Lucy Daniell, who came on the afternoon of Saturday 7 September 1844.

7. The Oldest Bungalow, and India House

Fair Outlook – the Earliest Surviving Bungalow

Hidden behind high walls in Spencer Road, a quiet street in Birchington-on-Sea, is a house that is very historic indeed. As the sign on the gatepost reveals, this is Fair Outlook and, to be precise, it is not a house but a bungalow – the earliest surviving original bungalow in the country.

Fair Outlook, plus a score of other bungalows and a Bungalow Hotel, were the result of a partnership between two architects: the visionary John Taylor (1818–84) and the astute, wealthy John Pollard Seddon (1827–1906).

Taylor had spotted a gap in the 1860s housing market. He realised there was a desire among richer Victorians for holiday homes away from the crowds and vulgarity of places such as Margate. There was also a desire for healthy living and, to some extent, for a simpler life with fewer servants dancing attendance.

Many in the professional classes had been posted for a time to India, often in Bengal, and had come to appreciate the houses they lived in there: simple, cool, mainly

Fair Outlook, the oldest surviving bungalow. (Birchington Heritage Trust)

Fair Outlook today. (Nick Barham)

single-storey structures surrounded by verandas. These houses were known as Banglas, or Bengalos, meaning 'of Bengal' and the word became Anglicised to bungalows.

Taylor reasoned that such houses would prove popular in England, but where to build them? It had to be in a place of relaxation and gentle refinement, yet within easy reach of London, where the purchasers would have their main homes. Margate was too busy, but there were more select options close by. First he chose the new resort of Westgate-on-Sea, built on grassland above low white cliffs just to the west of Margate, and designed to appeal to the metropolitan elite.

In 1869 John Taylor built four bungalows on the clifftop between Sea Road and Sussex Gardens. In a public-relations triumph the first was bought by Sir Erasmus Wilson, director of the Royal Sea Bathing Hospital in Margate, who we met in Chapter 1. Wilson was also Professor of Dermatology at the Royal College of Surgeons, the greatest authority on skin diseases of the nineteenth century, an antiquarian and – incidentally – the man who paid £10,000 to bring *Cleopatra's Needle* to London.

Wilson, a passionate advocate of the benefits of fresh sea air and salt water, raved about his purchase – aptly named The Bungalow – which stood alongside three others: Sea Lawn, Sea Tower and Cliff Lodge. In his thesis 'The Bungalow, 1600–1980', Anthony King says: 'Wilson was very pleased with his bungalow, flying a red flag whenever he was in residence.' Wilson wrote to the architect:

I find everybody charmed with my Bungalow and I believe if there were many bungalows, there would be many buyers. The house is a novelty, very convenient and

fitted for a single family and easy as to price ... They are novel, quaint, pretty and perfect as to sanitary qualities. The best sanitary home for a family is a bungalow.

With such an endorsement, and demand strong, Taylor looked for a place to build more bungalows. He found a spot where he could build a more extensive development a couple of miles east along the coast, at the newly founded Birchington-on-Sea.

Erasmus Wilson approved of the choice. He calculated that 'during a period of twenty-four hours a person would consume twice as much air at Birchington-on-Sea as he would given the same time in London'. He bought two bungalows there, and let them to wealthy patients in need of his sea cure.

In Birchington, Taylor's collaboration with John Pollard Seddon was crucial. Seddon had speculated by buying land here, hoping to cash in on the expansion of the railway along the coast. While Seddon kept ownership of the site, Taylor designed the bungalows – aimed at 'gentlemen of position and leisure'.

In *The First Bungalow Estate*, Alan Kay says the initial pair of Birchington bungalows were built in 1870 on either side of Coleman Stairs, a way down to the beach. They were named Fair Outlook and Poets Corner. 'In 1872 two more bungalows were built close by, Delmonte and White Cliffs, with Skyross added in 1873. These five bungalows were assured of "perfect privacy as there is no private right of way along the cliff". Between 1881 and 1882 four more bungalows were added to the line along the edge of the cliffs.' Taylor then seems to fade from the scene. He died two years later, but Seddon lived another twenty-two years. Seddon designed and built four bungalows of his own, in a private way off Spencer Road, and by 1891 there were thirteen in the clifftop estate, including Sea Tower and White Cliff.

A typical tower bungalow. (Birchington Heritage Trust)

Right: Sea Tower today.

Below: Sea Tower and other bungalows.

Kathryn Ferry includes this contemporary description of the smaller of two Taylor bungalow designs in her book *Bungalows*:

> There are eight rooms all on one floor. The two side rooms of the front elevations have doors into the garden, and are for dressing after bathing. There is a serving flap or buttery hatch from the kitchen in the dining room to economise labour of service ... Indeed the whole arrangement is such as to require the least amount of household work. There is a double-bedded room in the attic. A verandah at front and back gives coolness in summer ... The basement is sunk into the chalk and contains a larder, wine, beer, coal and general cellars.

The basement was an early example of refrigeration, and the bungalows incorporated other novel features including a lookout tower, a damp-proof course and patent interlocking roof tiles. Taylor designed modular 'chair' furniture that could be created in many different permutations from a simple set of component parts – like Ikea, but you decide if you want to make a wardrobe or a sofa!

Fronting Spencer Road are two sets of semi-detached Seddon houses, which started life as stables for the bungalows, with servants' quarters above. These have highly distinctive decoration depicting frolicking children, in sgraffito, a technique in which white plaster is applied over a coloured layer, and an image scratched into the white surface to reveal the colour underneath.

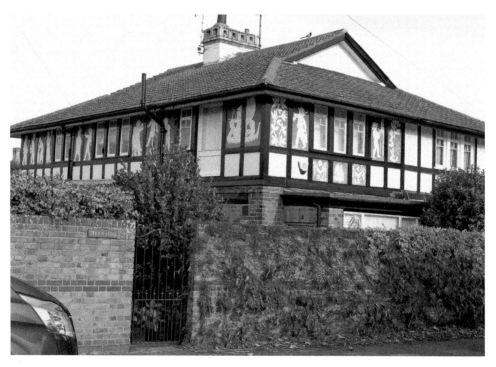

Sgraffito decoration on Tresco Lodge.

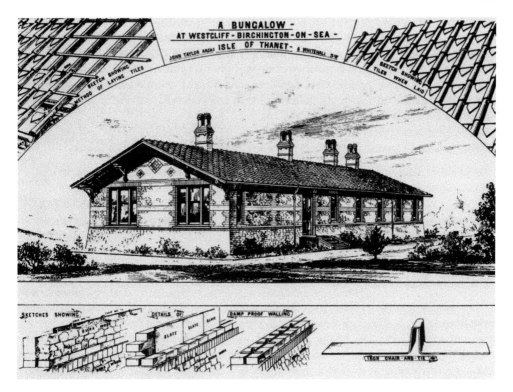

An advertisement demonstrating innovative tiles and foundations. (Birchington Heritage Trust)

They are the work of Sir George Frampton, who went on to create the Peter Pan statue in London's Kensington Gardens, the lions at the British Museum, and the Edith Cavell Memorial at the National Portrait Gallery.

Seddon also built bungalows in Beach Avenue, plus the Bungalow Hotel in the late 1870s. With its sign declaring 'No Stairs' it welcomed guests for over a century, but was demolished in 1984. As a child, the author Daphne Du Maurier spent many summer holidays and one Christmas at the Bungalow Hotel with her famous actor father Gerald Du Maurier and family.

Seddon's extensive contacts in London's literary and artistic circles drew many fashionable writers and artists. The Pre-Raphaelite painter Dante Gabriel Rossetti was among them. In 1882 Rossetti was very ill. His health had been destroyed by the copious amounts of alcohol and chloral he consumed to sedate himself and counter insomnia. John Seddon offered him a bungalow, The Chalet, which stood between Beach Avenue and what is now Rosetti Road, on the corner with Shakespeare Road. He accepted, arriving in February with the young novelist Hall Caine, who was something of a carer. The bungalow was later renamed after Rossetti.

The painter's move here helped neither his health nor his mood. Pat Orpwood in *The Rossetti Bungalow* writes that the artist 'could see neither beauty nor comfort in the place, fussed about his room and was only mollified after setting up his easel in a room with northern light'. Orpwood goes on: 'Rossetti missed all his London company and Caine

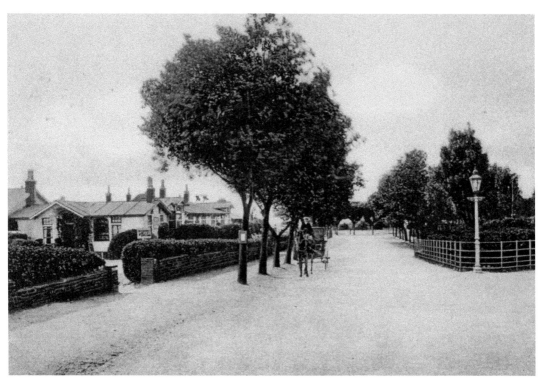

The Bungalow Hotel in 1906. (Birchington Heritage Trust)

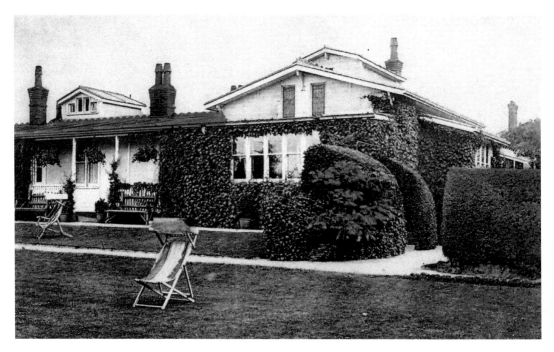

Rossetti's bungalow, called The Chalet when he lived here. (Birchington Heritage Trust)

wrote to his artist friends begging them to come down and visit. Many were busy on commissions, but ... Ford Maddox Brown popped down for a few days and did some drawings of Rossetti.'

Rossetti died on Easter Sunday, 9 April, and is buried at All Saints, Birchington. His memorial, a substantial Celtic cross made by Ford Maddox Brown, bears the inscription: 'Honoured among painters as a painter / And among poets as a poet'. A memorial window in the church, commissioned by Rossetti's mother, depicts a copy of his painting *The Passover in the Holy Family*.

So much evidence of John Taylor's invention has gone: Rossetti Bungalow was demolished in 1966. The last of the four original Westgate bungalows, Sea Tower, was replaced by flats in 2005, yet Taylor and Seddon's single-storey house was to have global repercussions.

Building News reported in 1870 that the concept had been picked up by architects in Australia and America. A 'Bungaloo Residence' was built in the Blue Mountains of New South Wales, and a timber bungalow constructed at Monument Beach, Cape Cod. These were the first of many to be built around the world, yet the bungalow has its roots in Westgate and Birchington.

DID YOU KNOW?
The commercial artist Louis Wain's paintings of soulful-eyed cats and kittens brought him huge fame. Between 1894 and 1917 he lived at Westgate-on-Sea, first at No. 16 Adrian Square, then No. 23 Westgate Bay Avenue and finally at No. 29. Each year he produced around 600 illustrations for greetings cards, book and magazines. His cats played golf, sported top hats and monocles, and sledged in the snow. Sadly his popularity diminished until, impoverished and mentally unwell, he ended his days in a psychiatric hospital, now painting abstracts, but still inspired by cats.

The India House – the First Seaside Retirement Home

Captain John Gould (1722–84) was a tea planter in Bengal and owned a fleet of ships that sailed between Deal and Calcutta for the East India Company. When, in 1767, he decided to retire to Margate, he built what Sir Nikolaus Pevsner would say, in *The Buildings of England* was 'the best house in Margate', basing it, according to an article in *Country Life*, on a similar house in Calcutta.

Gould is also believed to have been the first person to retire to the English seaside. The house he built in Hawley Street is described by Historic England, which gives it a Grade II* listing, as: 'A highly unusual eighteenth century house; possibly an early example of the genre of the eccentric seaside villa ... a crenelated Palladian villa on a diminutive scale.'

Captain Gould is not, however, the most interesting person to have lived in India House. That honour goes to Phyllis Broughton (1862–1926) a celebrated music hall actress and Gaiety Girl (a chorus girl in the Edwardian musical comedies performed at the Gaiety

India House, Hawley Street.

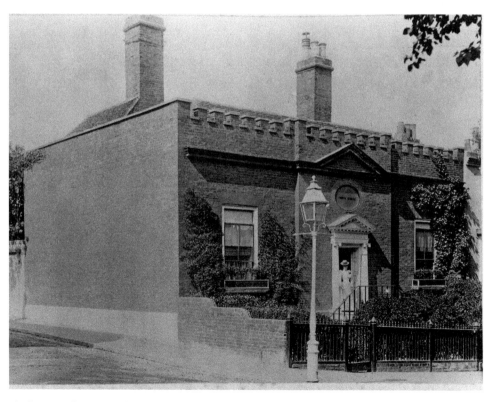

Phyllis Broughton outside India House. (Courtesy of Boys and Maughan)

Theatre in London's West End). She was known as 'the toast of toasts among young London clubmen' and one of the most beautiful women of her day. Among the shows she appeared in was *The Earl and the Girl* in 1903.

That title has a particular resonance when we look at Phyllis's life. In 1888 she became engaged to Henry Wellesley, Viscount Dangan, heir to Earl Cowley, but was jilted by him after four or five months of engagement. She sued for breach of promise and was awarded £2,500 in an out-of-court settlement. The case was a sensation. There was press speculation that Phyllis was copying another actress, May Fortescue, who had gained a substantial settlement from Earl Cairns in another breach of promise case.

The next year Phyllis became engaged again, to a wealthy colliery owner called John Hedley. Yet, a few days before their planned wedding, she ended their engagement in a curt telegram.

Headley was heartbroken, and never forgot her. When he died in 1936 he donated Longcroft, the mansion he had built in Hayes, Kent for them to live in, as a refuge for poor and elderly actors and actresses. The house had been maintained in pristine condition, but never lived in, since the day she rejected him.

India House was bought, in 1897, by Phyllis's stepfather, Lieutenant General Coote Synge-Hutchinson. Within a month, Synge-Hutchinson had passed the house to Phyllis, and she is believed to have lived there until 1917, when she married Robert Thompson, a doctor, former owner of India House, and the man who had sold it to her stepfather. Despite their shared histories of India House, the couple never lived there together, preferring London.

DID YOU KNOW?
William Temple, the only Archbishop of Canterbury to die in office, spent his final days in Westgate. Temple's horror at the persecution of Jews during the Second World War led him to found the Council of Christians and Jews with the then chief rabbi, and to campaign tirelessly for the most robust response possible to the Holocaust. His efforts exhausted him and brought on severe gout. He spent his final days at the Rowena Court Hotel (formerly The Bungalow), dying there on 26 October 1944. He is buried in Canterbury Cathedral, alongside his father, who had also been the archbishop.

Aesthetic Movement Sunflowers

If you should be wandering around Margate, admiring the buildings, you might notice a regular decorative element on a number of them: a terracotta panel depicting sunflowers.

The sunflower was adopted as a decorative motif by the Aesthetic Movement, which began in a small way in the 1860s in the studios and houses of radicals, including William Morris and Dante Gabriel Rossetti. Aestheticism was a reaction to the materialism of Victorian England, and its slogan was 'art for art's sake'. The movement, or at least its decorative flourishes, caught on, and by the 1890s had become mainstream.

One impressive example of Aesthetic Movement decoration is to be found at Hartsdown House, in Hartsdown Park, home of Margate FC. This 1873 Queen Anne Revival house features numerous sunflowers, for example on semicircular panels above windows. The Queen Anne Revival style typically includes red brick, white-painted sash windows and – often at the seaside – balconies. It can be found on villas in Westgate, but also on commercial properties, including shops in Margate High Street.

You will find sunflowers in Westgate on, for example, the Piggy Bank Day Nursery in Station Road, houses in Ethelbert Square, and the United Reformed Church in Westgate Bay Avenue. In Margate, they can be seen in the High Street, above the side entrance doorway at No 3 and on the second floor of the KFC at No 43.

DID YOU KNOW?
John Betjeman wrote a poem, 'Westgate-on-Sea', about the town. He describes standing on a balcony and hearing the 'happy bells' of St Saviour's parish church, and watching crocodiles of schoolchildren, purple-faced in the cold, trooping past the shops on the Parade. The poem ends with the evocative lines: 'Plimsolls, plimsolls in the summer/ Oh galoshes in the wet.'

Sunflower decorative motif at the Piggy Bank Nursery, Westgate.

A sunflower motif on the United Reformed Church, Westgate Bay Avenue.

8. Margate at War

Margate has always been on the front line. Sitting square on the Isle of Thanet, a fist of land poking temptingly out into the English Channel, it has looked enticing to invaders and would-be invaders from the Romans and Vikings to Napoleon and Hitler.

There have been many heroic episodes in Margate's wartime history, but perhaps the most dramatic and remarkable took place at RAF Manston, where a brilliant secret weapon was trialled and perfected: Barnes Wallis's Bouncing Bomb.

RAF Manston and the Bouncing Bomb

Locals knew for sure that there was something up when, on Sunday 11 April 1943, the beach between Margate and Herne Bay was declared a restricted zone and sealed off by police. Those who knew their aeroplanes had had inklings that something major was afoot over recent days, when they saw unfamiliar-shaped planes from Manston making repeated low-level runs out at sea between Birchington's Minnis Bay and Reculver.

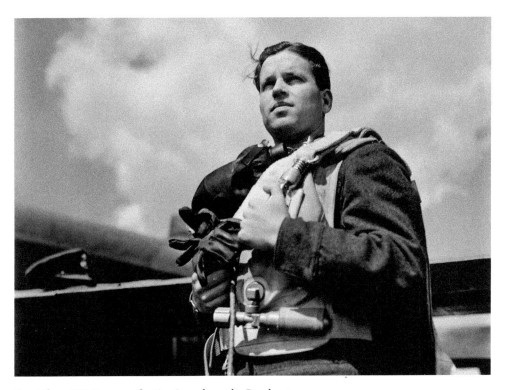

Guy Gibson VC, Commander 617 Squadron, the Dambusters.

Test version of an Upkeep bouncing bomb beneath a Lancaster.

Only those with special authorisation were to be allowed on that beach, among them an obscure aircraft designer called Barnes Wallis and a much-decorated bomber pilot called Wing Commander Guy Gibson. Yet, when Gibson flew down to RAF Manston a few days later, he found all was not ready for the secret trial flights his squadron would soon be making from Manston, learning how to deliver the new weapon.

The converted Mosquito, Wellington and Lancaster bombers were on station, as were stocks of two versions of the Bouncing Bomb, but further tests and adjustments had to be made on the ground before flights could commence. So when Gibson, commander of the recently formed 617 Squadron, and his bomber leader, Flight Lieutenant Bob Hay, turned up for a briefing in Hut 28 at Manston, they found there was nothing for them immediately to do. It was a warm spring day, so they decided to motor the 5 miles to Margate.

They found a town that was a sad shadow of its pre-war self. Where once there had been thirty first-class hotels, 210 smaller ones, and over 6,000 B&Bs, only two hotels and a handful of boarding houses remained open. In *Enemy Coast Ahead*, Gibson writes:

> It was pretty hard to realise, as we lounged on the beach, that this was the same old sunshine resort of peace-time ... Dreamland was an army barracks, barbed wire was everywhere and the place was full of soldiers. The only thing that remained was the fish.

We had just stuffed ourselves full of Dover soles and now felt pleasantly lazy in the early afternoon, listening to the screaming of the gulls as they glided over the harbour.

Suddenly there was a noise like the release of compressed air, then the chattering of cannon guns followed by the full crump of bombs. Like a flash, glinting in the sun at "nought" feet, four F. W. 190s [single-seater Focke-Wulf fighter planes] rocketed over our heads going flat out towards France, followed closely by four Typhoons ... Later in the evening we heard all four [190s] had been smacked down.

While Gibson and Hay were on the beach, Barnes Wallis was hard at work on his secret weapon. Two variants of the bomb were being tested, codenamed Upkeep and Highball.

Their targets were key dams in Germany's heavily industrialised Ruhr Valley, which supplied hydroelectric power and water for steel and other industries. If the dams could be destroyed, it would strike a devastating blow to Germany's war effort. The problem was that no aircraft of the time could carry a bomb big enough to breach the dams. However, if a smaller bomb could be exploded directly against the dam wall and well down beneath the water's surface, it might do the job. Barnes Wallis's task was to build such a bomb, and work out how it might be delivered.

He developed a spherical weapon, to be dropped from a low height, and spinning backwards. The bomb would bounce over the surface of the water and, when it hit the

The RAF Manston History Museum. (Nick Barham)

Remains of a dummy Upkeep bouncing bomb at RAF Manston. (Nick Barham)

wall of the dam, the backward spin would run it down until a specially designed fuse would explode it. It took over a month of trials to perfect the weapon.

During one hiatus while modifications were being made to the bombs, Guy Gibson and Bob Hay decided to take a spin in a borrowed open-cockpit, two-seater plane. What happened next could have been disastrous, both for them and for the mission codenamed Operation Chastise. As Gibson wrote, in *Enemy Coast Ahead*:

> When we were at 300 feet over Margate the engine stopped. Anywhere else it would be easy to put the machine down in a convenient field but at Hell's Corner [as this much-bombed corner of Kent was known] they make quite certain that aircraft do not land safely in fields. There were abundant wires and other devices because German glider-borne troops were not very welcome. So we fell into the trap … After the aircraft had rolled itself into a ball and we had stepped out of the dust a policeman arrived and took a statement. 'I'm glad to see our anti-invasion devices work' he said without sympathy.

They had come down in Birchington, crashing in a field at the top of Brooksend Hill.

The tests at Manston, and the many practice flights out over the sea, enabled the weapons to be perfected. Crucially, it was learned here that the Upkeep version of the bomb, the one used in the successful attacks, should be drum shaped, not spherical, as it had been up to now, 60 inches long and 51 inches wide.

The team also determined that the planes must fly at exactly 600 feet, travelling at 232 mph and that the bombs, when released, must spin backwards at precisely 500 rpm. On the night of 16–17 May 1943, the attacks were made successfully.

A dummy Upkeep bomb, recovered from the sea, is on display at RAF Manston History Museum, and what is believed to be the core of an early Highball, the smaller of the two weapons tested, is on show at the adjacent Spitfire and Hurricane Memorial Museum.

Tragically, Guy Gibson did not survive the war, dying in July 1944 when, returning from another raid on the Ruhr, he flew into a low hill in Holland.

DID YOU KNOW?
During the Second World War Margate's donkeys had a new role. *The Times* reported on 7 September 1942: 'The uses of adversity are well illustrated by the news of the Margate donkeys. They dwelt in a prohibited area and their occupation of carrying happy children or plump matrons for a ride on the sands is presumably gone. Undismayed they are making an admirable contribution to the war effort. Daily they are led round the town bearing sacks into which house-holders put their salvage.'

First World War Seaplanes at Westgate-on-Sea

The threat from U-boats lurking in the English Channel and Thames Estuary led, in June 1914, to the formation of a Royal Naval Air Station at St Mildred's Bay, Westgate-on-Sea. Seaplanes would be launched from the promenade via slipways, one of which is still evident today. These early planes were unreliable and pilots carried homing pigeons with them, which could take a message with a plane's location back to base if engine failure meant they had to ditch into the sea.

The public were not allowed to approach the slipways or the sheds in which the planes were stored, but they were free to stroll along the sands.

As Geoffrey Williams writes in *Wings Over Westgate*, there was also a growing threat of air raids on Margate and other Thanet towns. To counter them, an airfield was created at the top of the chalk cliffs, above the point at which the seaplanes were launched. Hangers were built, and the airfield opened in April 1915. The landing strip, right on the edge of the cliff, proved to be precarious. One pilot was said to have toppled over into the sea while attempting to land, but fortunately the tide was in and he was saved.

The problems with the airstrip worsened as night bombing increased. Launching planes from there in darkness was even more perilous and, after pilot Reginald Lord died while attempting to land at night, a base was developed at Manston, an area of flat farmland already used by pilots for emergency landings. From 1916, aeroplanes moved to Manston.

Seaplane slipway at Westgate-on-Sea.

In 1916 the seaplane base stood at bottom left. (Courtesy of Simon Moores under Creative Commons)

The seaplane station remained at Westgate and, by the end of the war, 200 personnel were based here. When the RAF was formed in April 1918, it became 219 Squadron RAF.

One former pilot, Philip Bristow, recalled his time flying a Short 184 seaplane at Westgate. He told the *Dorset Echo*: 'We were there to be the eyes of General Operations to watch the sea lanes, the Thames approaches, the southern North Sea and Straits of Dover, but we carried 230 lb bombs so we could attack a submarine if we found one.' He also had a machine gun on the wing above him.

> Westgate was a small station. We were all only about eighteen- or nineteen-years-old but we were all expert flyers. I had an observer behind me and we wore heavy coats and helmets because it was very cold in the open cockpit aircraft.
>
> You didn't want to be more than 1,000ft because you wanted to have a good view, yet be able to identify anything quickly. I came down three times in the North Sea with engine failure.

Philip died two weeks before his 102nd birthday, in November 2001.

DID YOU KNOW?
During the First World War, a coastguard at Birchington had a dog that was able to give vital early warnings of Zeppelin attacks. With his particularly attuned hearing the dog, Jim, could detect approaching airships on bombing missions long before they reached the coast, and raise the alarm.

John Betjeman on Margate in Wartime

Margate was a sorry sight during the Second World War, as John Betjeman noted in 'Margate, 1940'. Yet, in this poem recording impressions gained while staying here during the first year of the war, he saw the town as a powerful symbol of what we were fighting for.

Betjeman stayed at the Queen's Highcliffe, a once-smart hotel then in decline, on the Eastern Esplanade by Newgate Gap. He writes nostalgically of the putting greens and privet hedges, and the *thé dansant* at The Grand Hotel.

The Queen's Highcliffe, plus The Grand, were bought by Butlins in 1955 and later demolished, but in 1940 they reminded Betjeman of Margate's glory days. He remembers peacetime walks over the lawns by the Queen's Promenade and sunsets over Cliftonville's Harold Road and Norfolk Road.

He recalls the ground-floor restaurant's tables laid with sauce bottles and Kia-Ora, pictures children looking down over the town from the third- and fourth-floor balconies, and adults preparing for an evening of dancing and cards.

His poem's final stanza contrasts the rosy glow of the past with the present fear and foreboding, but the final line concludes with a powerful message about why Margate, and

those things Betjeman has recalled about it, matter so much: 'It is those we are fighting for, foremost of all.'

Over the past couple of decades, many people have also felt that Margate is worth fighting for. Sometimes by banding together, at other times through their own individual efforts, they have given Margate a future and made it something that, even at the height of its popularity, it has never been before: cool!

This book is dedicated to all of them.

DID YOU KNOW?
On 27 April 1944 two heavily damaged US Air Force Liberator aircraft crash-landed within hours of each other. One was destroyed when it came down heavily in shallow water 100 yards off the beach at Westgate, the other hit the clifftop at Foreness Bay, Cliftonville, exploded and caught fire. Both were returning from bombing missions, and attempting to make emergency landings at RAF Manston. At Westgate, where a memorial now stands, five crew were killed and four injured. At Foreness there were just two survivors, who managed to bail out just before impact.

Lido, Putting Green and Queen's Hotel, Cliftonville. ET 4613

The putting green and Queen's Highcliff Hotel in the 1960s.

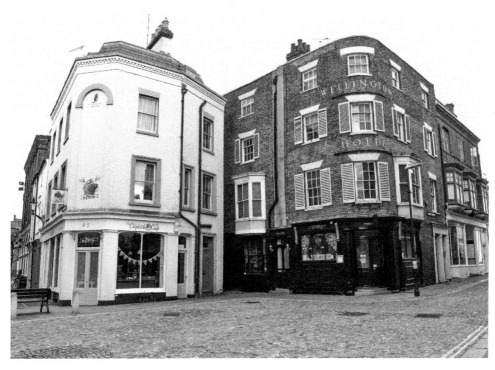

Cupcake Café and Kentish Pantry are among the businesses transforming Margate.

Turner Contemporary – revitalising Margate Harbour. (Stephen White)

Bibliography

In writing this book, I have read or consulted the following books, publications and websites:

Anderson, John, *A Practical Essay on the Good and Bad Effects of Sea-water and Sea-bathing* (London: Dilly, 1795)

Austen-Leigh, William and Austen-Leigh, Richard Arthur, *Jane Austen, Her Life and Letters* (London: Smith, Elder & Co., 1913)

Bailey, Anthony, *Standing in the Sun: A Life of J. M. W. Turner* (London: Tate, 1997)

Barker, Nigel et al, *Margate's Seaside Heritage* (Swindon: English Heritage, 2007)

Betjeman, John, *New Bats in Old Belfries* (London: John Murray, 1945)

Clarke, Tim, *The Countess: The Scandalous Life of Frances Villiers, Countess of Jersey* (Stroud: Amberley Publishing, 2016)

Coleman, George Sanger, *The Sanger Story* (London: Hodder and Stoughton, 1956)

Conrad, Tweed, *Oscar Wilde in Quotation* (London: McFarland, 2006)

Cozens, Zechariah, *Tour Through the Isle of Thanet* (London: J. Nichols, 1793)

Daily News (31 October 1882)

Defoe, Daniel, *Tour Through the Whole Island of Great Britain* (London: S. Birt, 1724–7)

Dictionary of National Biography (Oxford: Oxford University Press, 2016)

Emin, Tracey, *Strangeland* (London: Hodder and Stoughton, 2005)

Ferry, Kathryn, *Bungalows* (Oxford: Shire Publications, 2014)

Fisher, Thomas, *The Kentish Traveller's Companion* (Rochester: T. Fisher, 1793)

Gibson, Guy, *Enemy Coast Ahead* (London, Goodall, 1986)

Goddard, Julie, *Oh! What a Circus* (Berkshire Family History website, https://www.berksfhs.org.uk/journal/Sep2000/Sep2000OWhatACircus.htm)

Hall, Joseph, *Hall's New Margate and Ramsgate Guide* (Margate: Hall's, 1790)

Hamilton, James, *Turner: A Life* (London: Sceptre, 1997)

History of Manston Airfield https://www.manstonhistory.org.uk/dambuster-bouncing-bomb-tests-at-reculver-and-manston/

Inhabitant, An, *The Margate Guide* (Margate: Thanet Press, 1807)

James, William, *Naval History of Great Britain*, Volume 2 (London: Conway Maritime Press, 2003)

Jones, Lesley-Anne, *Hero: David Bowie* (London: Hodder & Stoughton, 2016)

Jones, Lesley-Anne, 'Margate Deserves a David Bowie Memorial as Much as Brixton and Berlin' in the *Daily Telegraph* (16 October 2017)

Kay, Alan, *The First Bungalow Estate* (Birchington: Birchington Heritage Trust, 2002)

Kent Gardens Trust, 'Hawley Square', https://www.kentgardenstrust.org.uk/research-projects/Thanet/Hawley%20Square%20.pdf

Kentish Chronical (January 1808)

Kidd's Picturesque Pocket Companion to Margate, Ramsgate and Broadstairs (London: William Kidd, 1831)

King, Anthony Douglas, 'The Bungalow 1600–1980' (Uxbridge: Brunel University PhD thesis, 1982)

Laister, Nick, *The Amusement Park: History, Culture and the Heritage of Pleasure* (London: Routeledge, 2017)

Lamb, Charles, *Essays of Elia* (London: Edward Moxon, 1833)

Lee, Anthony, *Margate Before Sea Bathing: 1300 to 1736* (Margate: CreateSpace Independent Publishing Platform, 2015)

Lee, Anthony, *Margate in the Georgian Era* (Margate: Droit House Press, 2012)

Lee, Anthony, 'The Reverend Wood Visits the Zoo' (Margate: Margate Local History https://www.margatelocalhistory.co.uk/Articles/wood.pdf)

LeGear, Rod, *Undergound Thanet* (Birchington: Trust for Thanet Archeology, 2012)

Leslie, Anita, *Mrs Fitzherbert A Biography* (New York: Scribner, 1960)

Macadam, Sheila and Edwin, 'Thanet's Baths and Bathing Machines in the Nineteenth and Twentieth Centuries', http://www.shelwin.com/e/Thanet_Research/pt_baths.pdf

'Margate Coastal Park' (Kent: Kent Gardens Trust, https://www.kentgardenstrust.org.uk/research-projects/Thanet/The%20Margate%20Coastal%20Park.pdf)

Marsh, Patricia Jane, *The Enigma of the Margate Shell Grotto* (Canterbury: Martyrs' Field, 2011)

Moyle, Franny, *The Extraordinary Life and Momentous Times of J. M. W. Turner* (London: Penguin Press, 2016)

Orpwood, Pat, *The Rossetti Bungalow* (Birchington: Birchington Heritage Trust, 2004)

Oulton, W. C., *Picture of Margate, and its Vicinity* (London: Baldwin, Cradock and Joy, 1809)

Ovenden, Toby, *The Cobbs of Margate: Evangelicalism and Anti-slavery in the Isle of Thanet, 1787–1834* (Maidstone: Kent Archeological Society, 2013)

Richardson, Harriet, 'Margate's Sea-bathing Hospital', https://historic-hospitals.com/2017/12/27/margates-sea-bathing-hospital/

Robinson, Janet, 'A Branch of the Jarvis Family' (Margate: Margate Local History http://www.margatelocalhistory.co.uk/DocRead/Jarvis%201%20Family.html)

Sanger, George 'Lord', *Seventy Years a Showman* (New York: E. P. Dutton, 1910)

Smart, Alistair, 'J. M. W. Turner's Kent' (*Daily Telegraph*, 21 February 2012)

Smith, Janet, *Liquid Assets* (London: English Heritage, 2005)

St Clair Strange, F. G.: *The History of the Royal Sea-bathing Hospital Margate 1791–1991* (Rainham: Meresborough Books, 1991)

The Land We Live In: A Pictorial and Literary Sketch-book of the British Empire (London: Charles Knight, 1849)

The Times (29, 30 November and 4 December 1911)

Warrell, Ian, *J. M. W. Turner* (London: Tate Publishing, 2007)

Whyman, John, *The Early Kentish Seaside (1736–1840)* (Maidstone: Kent Archives Office, 1985)

Williams, Geoffrey, *Wings over Westgate* (Maidstone: Kent County Library, 1985)

Acknowledgements

The author would like to thank the following people/organisations for permission to use copyright material in this book: the Wellcome Collection for numerous images from its archive; the Royal Collection Trust for *Summer Amusement at Margate*, James Gillray; Dreamland for images of the renovated park; Tate Britain for Turner's *Fishermen at Sea*; Turner Contemporary for several images associated with the gallery; Alamy for the images of Tracey Emin and of the Shell Grotto; wobble-san, under Creative Commons, for the picture of Pete Docherty; Jennie Burgess of the Birchington Heritage Trust for her assistance with photographs of the Bungalows of Birchington; Ian Priston of Boys & Maughan Solicitors, current occupants of India House, for assistance in obtaining the picture of Phyllis Broughton on the steps of the house; and Simon Moores, under Creative Commons, for the aerial view of Westgate.

I would also like to acknowledge the enormously valuable online resource of the Margate Local History site, www.margatelocalhistory.co.uk, compiled by Anthony Lee.

Every attempt has been made to seek permission for copyright material used in this book. However, if we have inadvertently used copyright material without permission/acknowledgement we apologise and will make the necessary correction at the first opportunity.